ELUSIVE SIGNS Bruce Nauman Works with Light

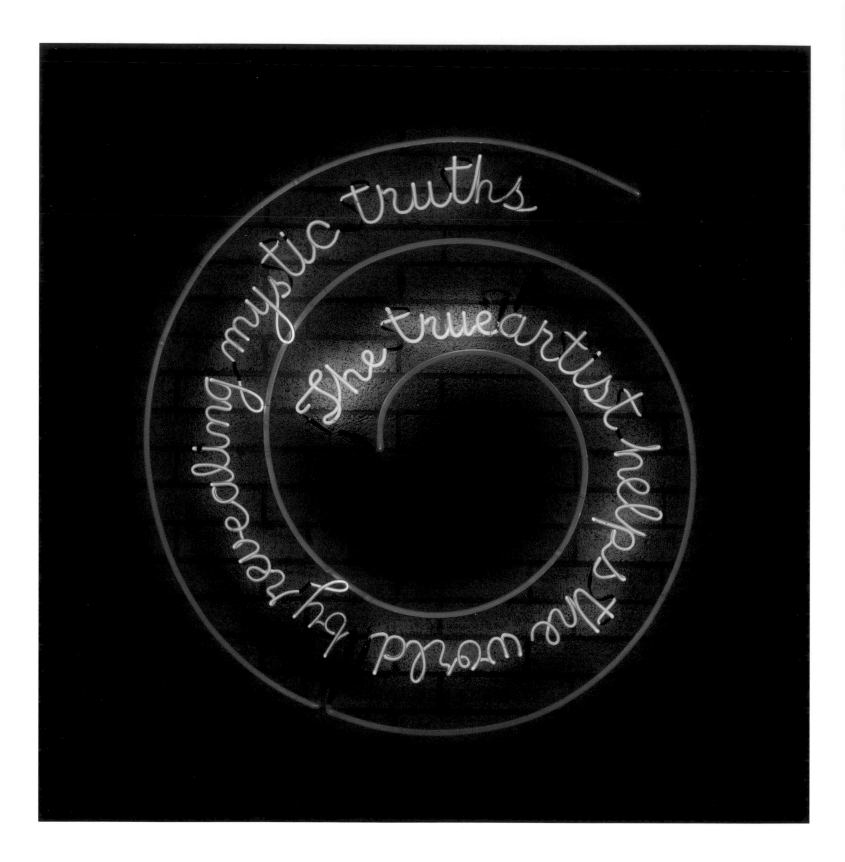

1 The True Artist Helps the World by Revealing
 Mystic Truths (Window or Wall Sign), 1967.
 Collection Kröller-Müller Museum, Otterlo,
 The Netherlands

ELUSIVE SIGNS Bruce Nauman Works with Light

JOSEPH D. KETNER II

ESSAYS BY

JOSEPH D. KETNER II, JANET KRAYNAK, GREGORY VOLK

MILWAUKEE ART MUSEUM | MILWAUKEE, WISCONSIN

THE MIT PRESS | CAMBRIDGE, MASSACHUSETTS | LONDON, ENGLAND

This catalogue has been published on the occasion of the exhibition
Elusive Signs: Bruce Nauman Works with Light, organized by the
Milwaukee Art Museum and presented from 28 January to 9 April 2006.

ADDITIONAL VENUES

Indianapolis Museum of Art, Indiana

14 MAY–6 AUGUST 2006

Museum of Contemporary Art, North Miami, Florida

14 OCTOBER 2006–7 JANUARY 2007

Henry Art Gallery, University of Washington, Seattle

10 FEBRUARY–6 MAY 2007

Musée d'art contemporain de Montréal, Montreal, Canada

25 MAY–3 SEPTEMBER 2007

Australian Centre for Contemporary Art, Victoria, Australia

9 OCTOBER–7 DECEMBER 2007

Queensland Art Gallery, South Brisbane, Australia

JANUARY–APRIL 2008

TABLE OF CONTENTS

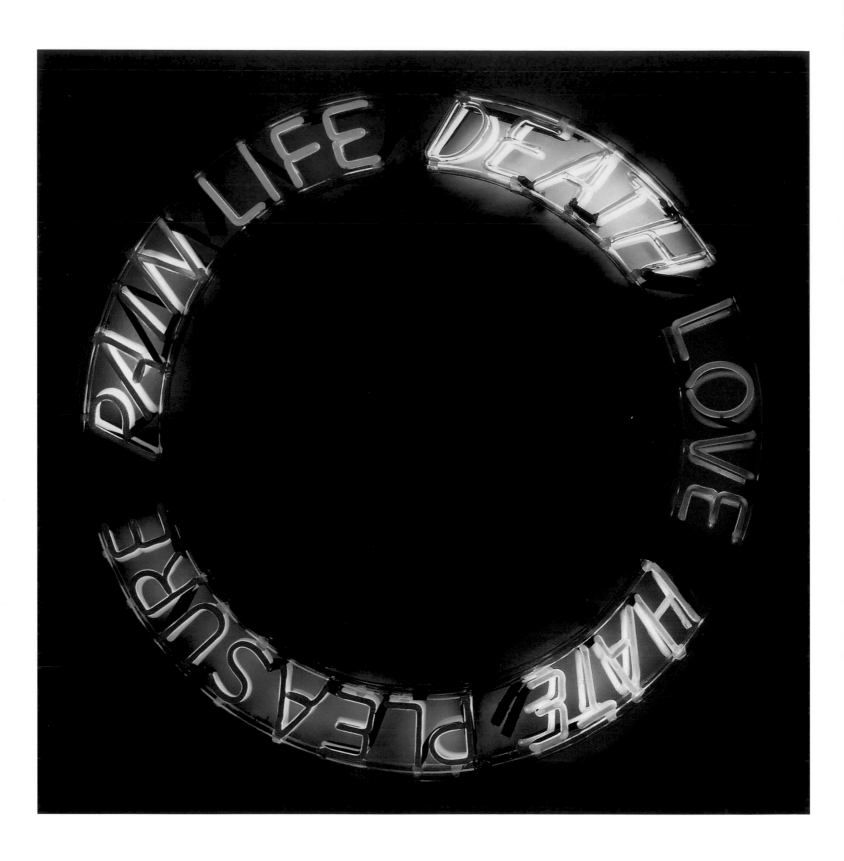

FOREWORD

DAVID GORDON DIRECTOR AND CEO MILWAUKEE ART MUSEUM

Bruce Nauman deals with the big questions of life, in the words of his 1983 neon: *Life, Death, Love, Hate, Pleasure, Pain* (fig. 2). The work is a circle of words, flashing on and off in succession, that name the essential elements of human experience. At the same time, the presentation suggests the forces in modern society that lead to sound bites and instant gratification. Advertising slogans are symptomatic of these forces, and neon is their powerful handwriting. So, how appropriate to use neon in a reductive way to alert us to the dangers of oversimplification. Nauman begs us to *Please Pay Attention Please* (1973) to fundamental aspects of life, or, more confrontationally, commands us to *Pay Attention Motherfuckers* (1973, fig. 3). We need to be shocked out of our childlike complacency by art's critique and wake up to the power of words that are used in the web of manipulation of consumer culture. The tension between the apparent simplicity and actual sophistication of Nauman's commentary on the circle of life makes him one of the most important of living artists.

Nauman had his first exhibition at Nicholas Wilder Gallery in Los Angeles immediately after completing his graduate school studies at the University of California, Davis, in 1966. In that show, he presented fiberglass sculptures derived from his earlier paintings. Only two years later he had his first New York exhibition at Leo Castelli and in 1972 his first retrospective, organized jointly by the Los Angeles County Museum of Art and the Whitney Museum of American Art. Remarkable as this was for a young artist, his work was greeted with ambivalence. Ivan Karp, then at Castelli Gallery, described the inaugural New York show as "spotty," saying that Nauman was "not a remarkable artist."[1] Robert Pincus-Witten and Peter Plagens, important critics of the era, also responded with reservations. Plagens felt that "too much was already written about an artist just out of graduate school."[2] Yet, he praised *Green Light Corridor* (1969, fig. 4) as "the best piece that Nauman has ever done."[3] Pincus-Witten felt that the early works were "adolescent and contemptible," but admitted that "he deals with serious issues" and that his neon works alone "ranked him as an important figure."[4]

2 **Life, Death, Love, Hate, Pleasure, Pain**, 1983.
Museum of Contemporary Art, Chicago,
Gerald S. Elliott Collection

Like the jazz musicians Nauman admires, the artist was much more warmly received in Europe than in the U.S., where the public was slow to accept his work. His reputation finally began to soar here in the 1990s, leading to a monumental retrospective in 1994 organized by the Walker Art Center, which traveled to Europe and through the States. Despite this recognition, the artist continued to earn mixed reviews from reviewers such as Arthur C. Danto, who referred to his "smartass" word games in that "nosy awful exhibit."[5] Yet, the general critical consensus was that Nauman should be proclaimed "the best—the essential—American artist of the past

quarter-century." The litany of praise grew to the point where the popular press anointed him a "hero." As *New York Times* critic Michael Kimmelman noted, "he inspires reverence, or loathing.… It's hard to feel indifferent to work like his."[6]

Elusive Signs: Bruce Nauman Works with Light is Nauman's first solo exhibition in Wisconsin, the state in which he was raised from an early age. His father worked for General Electric and the family moved often. Nauman went to the University of Wisconsin–Madison for his undergraduate work, and some of his family still lives in Wisconsin.

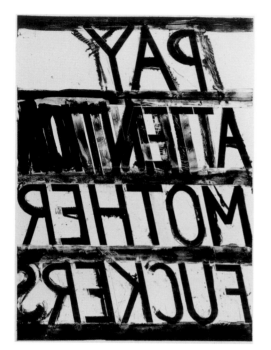

The Milwaukee Art Museum has a century-long tradition of originating important contemporary art exhibitions, including *Henry O. Tanner* (1913), *The Modern Spirit* (1914), *László Moholy-Nagy Photographs* (1931), *Pop Art: The American Tradition* (1965), *Light/Motion/Space* (1969), *Currents 2: New Figuration from Europe* and *New Figuration in America* (1982), *Warhol/Beuys/Polke* (1987), *Word As Image* (1990), and *Identity Crisis: Self-Portraiture at the End of the Century* (1997). The Bruce Nauman show is a significant addition to this list. *Elusive Signs: Bruce Nauman Works with Light* is the first exhibition that Joe Ketner has curated at the Milwaukee Art Museum, where he became chief curator on 1 June 2005. The combination of scholarship and imagination he displayed in the exhibition and catalogue augurs well for the future. Joe began to work on the project while he was the Henry and Lois Foster Director of The Rose Art Museum at Brandeis University. I would like to thank its provost, Marty W. Krauss, for her kindness and generosity over the transition arrangements.

The exhibition has posed unusual technical and legal challenges. Due to the fragility of neon, it is impractical to ship these works around the globe. Thus, as is standard practice, they were recreated. We would like to thank the artist and the owners of the works and their representatives for allowing us to use the copyrights: Director Doreen Bolger, The Baltimore Museum of Art; Curator Yuji Akimoto, Benesse Art Site Naoshima, Japan; Curator Carla Schultz-Hoffmann, Udo and Anette Brandhorst Collection, Cologne; Director Tom Eccles, Center for Curatorial Studies, Bard College, Annandale-on-Hudson; Collections Manager Patrick Peternader, Friedrich Christian Flick Collection, Berlin; Director Lisa Dennison, Solomon R. Guggenheim Museum, New York; Camille O. Hoffmann, Chicago; Collections Manager Sandra Smith, Estate of Philip Johnson, courtesy the National Trust for Historic Preservation; Director Robert Fitzpatrick and Curator Elizabeth Smith, Museum of Contemporary Art, Chicago; Director Evert J. Van Straaten, Rijksmuseum Kröller-Müller, Otterlo, Netherlands; Director Gijs van Tuyl, Stedelijk Museum, Amsterdam, who himself organized a retrospective of the artist's work when he was director of the Wolfsburg Museum, Germany, in 1997; Donna and Howard Stone, Chicago; and Director Nicholas Serota and Director of Collections Jan Debbaut, Tate Gallery, London.

In addition, we want to thank individuals who enthusiastically agreed to host the *Elusive Signs* exhibition at their respective venues: Associate Curator of Contemporary Art Lisa Freiman and Exhibitions Manager Sue Ellen Paxton, Indianapolis Museum of Art; Director Bonnie Clearwater, Museum of Contemporary Art, North Miami (in our second collaboration); Curator Elizabeth Brown and Exhibitions Manager Paul Cabarga, Henry Art Gallery, University of Washington, Seattle; Director Marc Mayer, Chief Curator Paulette Gagnon, and Curator Sandra Grant Marchand, Musée d'art contemporain de Montréal; Artistic Director Juliana Engberg, Australian Centre for Contemporary Art, Victoria—Juliana was kind enough to coordinate the Australian tour—and Director Doug Hall, Queensland Art Gallery, South Brisbane.

And, finally, a note of appreciation for our sponsors, Andy and Carlene Ziegler. Andy, our new president, wanted to show his support for Joe, our new chief curator, by sponsoring his maiden Milwaukee Art Museum exhibition. We are most grateful for this act of neon-enlightened patronage.

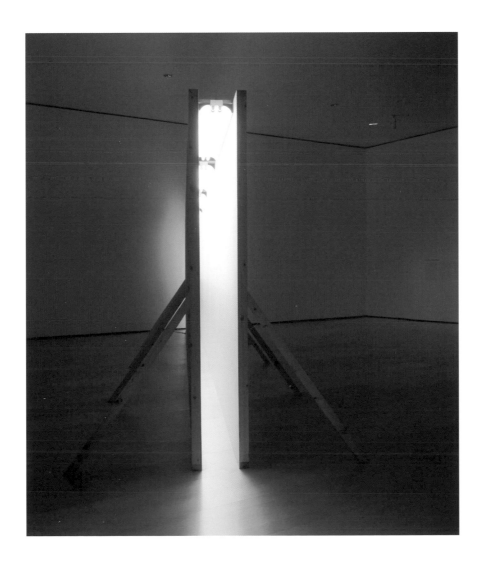

LENDERS TO THE EXHIBITION

The Baltimore Museum of Art, Maryland

Benesse Art Site Naoshima, Naoshima, Japan

Udo and Anette Brandhorst, Cologne

Center for Curatorial Studies, Bard College, Annandale-on-Hudson, New York

Friedrich Christian Flick

Solomon R. Guggenheim Museum, New York

Camille O. Hoffmann, Chicago

Estate of Philip Johnson, courtesy the National Trust for Historic Preservation

Museum of Contemporary Art, Chicago

Rijksmuseum Kröller-Müller, Otterlo, Netherlands

Stedelijk Museum, Amsterdam

Donna and Howard Stone, Chicago

Tate Gallery, London

ACKNOWLEDGMENTS

JOSEPH D. KETNER II CHIEF CURATOR MILWAUKEE ART MUSEUM

In 1990, Ronald Greenberg of Greenberg Van Doren Gallery in St. Louis showed me a set of Bruce Nauman's drawings—more like diagrams—for a fluorescent light installation that the artist had created for Joe Helman's St. Louis gallery in 1971. At that time, Greenberg and Helman were partners, starting their careers as gallerists and taking a risk on the emerging Nauman to create a novel installation for their space. The installation intrigued me. As the director of the Washington University Gallery of Art (now the Mildred Lane Kemper Art Museum) in St. Louis, I convened the staff to discuss how we might recreate this landmark exhibition. The result was a small exhibition, *Bruce Nauman: Light Works* (1993), which included the *Helman Gallery Parallelogram* (1971, fig. 15) surrounded by several neons. Though modest, the show was spectacular and challenging, but went unnoticed. Some twelve years later, when I was director of The Rose Art Museum at Brandeis University, I contacted Bruce Nauman and his long-time studio assistant, Juliet Myers, to discuss expanding this project into a larger exhibition and a publication for a wider public. They agreed.

Certainly, it may seem irrational to isolate one medium in an artistic production as varied as Nauman's. But the inherent contradiction is part of the concept's curiosity. It is incontrovertible that the medium of light—an intangible, non-art material—was important to the artist over the first two decades of his career. As I proceeded to develop the idea, I was buoyed by the advice and support of the artist and Ms. Myers. I am grateful to them for guiding the project and checking my thinking when it ventured down wayward paths. Doubtless I am not alone in expressing appreciation to Bruce Nauman, whose work motivates so many to think new thoughts.

It is difficult to make a new contribution to the voluminous literature on Nauman, whose art has been hotly discussed in contemporary criticism and scholarship. Yet, this volume offers fresh perspectives on Nauman. Janet Kraynak is perhaps the most authoritative new voice on his work, having published a collection of writings on and by him, and currently writing a book on his early production. Gregory Volk is an imaginative writer with whom I have worked in the past and continue to admire for his innovative, literary approach. Both authors enthusiastically agreed to participate in this project and helped shape the development of this publication.

I consulted with several colleagues in the profession about various aspects of the project. Constance Lewallen, senior curator for exhibitions at the University of California, Berkeley Art Museum, with whom we coordinated plans for our respective Nauman shows; Susan Cross,

associate curator at the Solomon R. Guggenheim Museum, whose own exhibition *Bruce Nauman: Theaters of Experience* (2003) served as a model for examining Nauman's work in a focused way; and Dietmar Elger, curator of the Sprengel Museum in Hannover, Germany, who organized *NEONstücke* in 1990, and advised me on the logistics of organizing a large-scale neon exhibition. I also wish to thank Bernice Rose of Pace Wildenstein Gallery, who readily helped secure existing exhibition copies of Nauman's neons. Jacob Fishman of Light Writers, Chicago, was critical to the success of this project. Jake is the principal fabricator of Nauman's neons and has reproduced a large number of his works. We spent many hours talking about the neons. It was a rare circumstance in which the fabricator played such an instrumental role in the selection of the final checklist.

I am grateful to Ronnie Greenberg for having initially shown me the drawings for *Helman Gallery Parallelogram* and to Joe Helman for assisting me with the details attendant on reconstructing the room. I want to acknowledge the vital role played by Dorothee Fischer, Konrad Fischer Galerie, Düsseldorf; Rhona Hofman, Chicago; Angela Westwater, Sperone Westwater, New York; and Donald Young, Chicago, all longstanding dealers of Nauman's work who provided important guidance on potential lenders and venues.

I owe a debt of gratitude to Brandeis University for supporting my work during the conception of this exhibition. For two years, Eliza Jacobs (Brandeis '05) served as my research assistant on this project and performed professional-caliber work. At the Milwaukee Art Museum, Curatorial Assistant Heather Winter tackled the difficult task of gathering the images and reproduction permissions for the catalogue, serving an important role in determining the visual contents of the book.

It is entirely a fortuitous circumstance that *Elusive Signs* is my first exhibition as chief curator at the Milwaukee Art Museum, the city in which Bruce Nauman grew up. Forty-two years after graduating from the University of Wisconsin–Madison, Nauman will have his first solo museum exhibition in this state. It is gratifying that this presentation focusing on an international artistic figure of Bruce Nauman's stature is originating in the place of his youth.

LIVE AND DIE	LIVE AND LIVE	SING AND DIE	SING AND LIVE
DIE AND DIE	DIE AND LIVE	SCREAM AND DIE	SCREAM AND LIVE
SHIT AND DIE	SHIT AND LIVE	YOUNG AND DIE	YOUNG AND LIVE
PISS AND DIE	PISS AND LIVE	OLD AND DIE	OLD AND LIVE
EAT AND DIE	EAT AND LIVE	CUT AND DIE	CUT AND LIVE
SLEEP AND DIE	SLEEP AND LIVE	RUN AND DIE	RUN AND LIVE
LOVE AND DIE	LOVE AND LIVE	STAY AND DIE	STAY AND LIVE
HATE AND DIE	HATE AND LIVE	PLAY AND DIE	PLAY AND LIVE
FUCK AND DIE	FUCK AND LIVE	KILL AND DIE	KILL AND LIVE
SPEAK AND DIE	SPEAK AND LIVE	SUCK AND DIE	SUCK AND LIVE
LIE AND DIE	LIE AND LIVE	COME AND DIE	COME AND LIVE
HEAR AND DIE	HEAR AND LIVE	GO AND DIE	GO AND LIVE
CRY AND DIE	CRY AND LIVE	KNOW AND DIE	KNOW AND LIVE
KISS AND DIE	KISS AND LIVE	TELL AND DIE	TELL AND LIVE
RAGE AND DIE	RAGE AND LIVE	SMELL AND DIE	SMELL AND LIVE
LAUGH AND DIE	LAUGH AND LIVE	FALL AND DIE	FALL AND LIVE
TOUCH AND DIE	TOUCH AND LIVE	RISE AND DIE	RISE AND LIVE
FEEL AND DIE	FEEL AND LIVE	STAND AND DIE	STAND AND LIVE
FEAR AND DIE	FEAR AND LIVE	SIT AND DIE	SIT AND LIVE
SICK AND DIE	SICK AND LIVE	SPIT AND DIE	SPIT AND LIVE
WELL AND DIE	WELL AND LIVE	TRY AND DIE	TRY AND LIVE
		FAIL AND DIE	FAIL AND LIVE
WHITE AND DIE	WHITE AND LIVE	SMILE AND DIE	SMILE AND LIVE
RED AND DIE	RED AND LIVE	THINK AND DIE	THINK AND LIVE
YELLOW AND DIE	YELLOW AND LIVE	PAY AND DIE	PAY AND LIVE

ELUSIVE SIGNS Bruce Nauman Works with Light

JOSEPH D. KETNER II CHIEF CURATOR MILWAUKEE ART MUSEUM

Elusive Signs focuses on Bruce Nauman's neons and light-room installations, a visually engaging and intellectually provocative body of work in which light defines the artist's language. Beginning with his earliest artistic production and continuing through the first two decades of his career, Nauman worked extensively with sources of illumination, including fluorescent, incandescent, neon, and sodium lights.[1] Their radiance—though immaterial—aggressively penetrates the environment, physically engaging us, assaulting us with their garish glow and forcing us to respond to their disturbing messages. Yet they can also be sensual and contemplative, seductive in their bold color, flashing lights, and pithy puns.

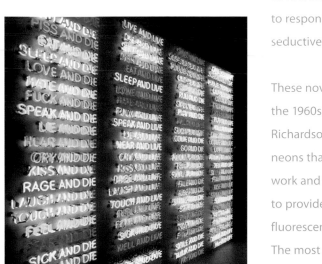

5 **One Hundred Live and Die**, 1984. Benesse Art Site Naoshima, Naoshima, Japan

These novel works attracted considerable attention when they were first exhibited in the 1960s and 1970s, culminating in the 1983 exhibition of Nauman's neons that Brenda Richardson organized for the Baltimore Museum of Art. Richardson catalogued the twenty-six neons that Nauman had produced up to that time and interpreted them in the context of his work and the neon and light art of the period.[2] *Elusive Signs* expands on this pioneering study to provide an overview of the entirety of Nauman's work with light, including his corridors, fluorescent light rooms, and the large number of neons that postdate Richardson's exhibition. The most significant of these is *One Hundred Live and Die* (1984, fig. 5), his most ambitious neon, and a host of figurative works from the mid-1980s. The conjoining of neons and light environments echoes Nauman's 1984 exhibition at Leo Castelli Gallery, New York. There he made a statement about the extremes in his art by contrasting the austere and depressing *Room with My Soul Left Out, Room that Does Not Care* (1984, fig. 6) with the dynamic, monumental *One Hundred Live and Die*. *Elusive Signs* follows this logic and is predicated on the premise that an examination of a focused body of Nauman's work can inform a broader range of the artist's production.

Light and space offered Nauman a fertile medium with which to confront the issues of how meaning is conveyed and perception shaped and what ultimately constitutes the nature of the human condition. These are the questions the artist has been grappling with since the beginning of his production, twisting and turning language, logic, and meaning with a sense of humor that is sometimes earnest and sometimes ironic. Throughout his art Nauman adopts an irreverent attitude to the investigation of the serious issues of art and life by resorting to games, nonsense, and inherent contradiction. As Freud theorized, it is sometimes through jokes, dreams, malapropisms, and the irrational that the deep, antithetical human urges are revealed. Walt Whitman claimed "contradiction" as his own domain, that is, the domain of the artist: "Do I contradict myself? Very well, then I contradict myself, I am large, I contain multitudes."[3]

Contra Diction/No Iconic Art

It is an inherent contradiction to focus on one medium in the work of an artist for whom such distinctions are irrelevant. Nauman's art is motivated by ideas, not a slavish fealty to a particular material. He varies his process to meet the demands of his thinking. With characteristic modesty, he outlined his methodology in an early interview as follows: "Rather than having a 'formal program,' like Stella, I always came in from the back door.... I had just a few ideas. But I wanted to put ideas into the works—mainly to put language into the work."[4] But he did not simply put words into his art. He manipulated language to produce multiple, even contradictory meanings. Throughout his career he has repeatedly referred to the paradox of making "things for people to see, and at the same time making them as hard as possible for people to see."[5] As he has said, "I like that confusion."[6] He has expressed his intention of invoking "the tension of giving and taking away, of…setting some kind of expectations and then not allowing them to be fulfilled."[7] In his light works, he exposes the schism between words and their perceived meaning in order to open language to new interpretations and new visual possibilities.

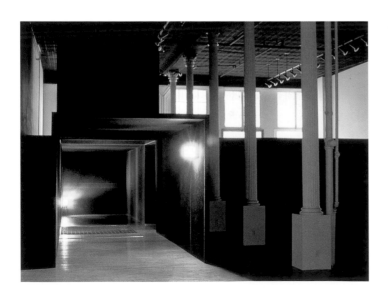
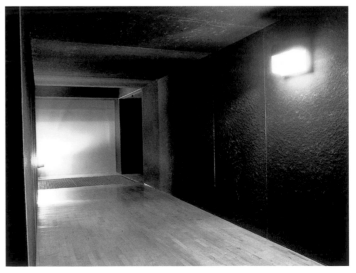

True to the spirit of Nauman's aesthetic, the very name of *Elusive Signs* is a contradiction in terms. The "elusive" nature of light is a contravention of the primary purpose of a "sign," which is to adamantly state its directive, whether to sell beer or to stimulate thinking. Although his flashing lights dance fleetingly across our retina, Nauman authoritatively commands us to "Fuck and Die/Fuck and Live," leaving an indelible impression. The sensory overload from the acidic colors that flood the fluorescent rooms, is, ironically, created by the absence of other colors. The experience can be calm or anxious, and the artist relishes playing these opposites against each other. The light works have a demonstrative presence, yet the effervescence of the medium makes it elude our powers to grasp its precise dimensions and shape. In sum, contradiction is a central aspect of all of these works.

Perhaps the most intriguing contradiction of *Elusive Signs* is that the exhibition contains no original works of art. Each neon and installation is an exhibition copy, a refabrication manufactured according to the artist's templates and specifications. In fact, Nauman did not even create the original neons and rooms himself—he had them fabricated. Early in his career, the artist decided that he was not interested in "adding to a collection of things that are art." About his first neons Nauman said: "I had the idea that I could make art that would kind of disappear, an art that was supposed to not quite look like art." He hired craftsmen to create "signs just like any other sign" that could melt into the environment, hang on a wall, or in a window.[8] For Nauman, the significance of the work lies in its message, not in the person who physically made the object. He adopted this notion from minimalist and conceptual prede- cessors like Sol LeWitt and Lawrence Weiner, who debunked the notion of the sanctity of the original objet d'art by providing instructions for others to manufacture their art. Ironically, Nauman did create an extraordinary collection of works that address the epistemology and ontology of art.

6 **Room with My Soul Left Out, Room that Does Not Care**, 1984. Friedrich Christian Flick Collection

As early as his days in graduate school in the mid-1960s, Nauman began to question the nature and purpose of art. "What I am really concerned about is what art is supposed to be—and can become. It seems to me that painting is not going to get us anywhere, and most sculpture is not going to, either, and art has to go somewhere."[9] The young artist abandoned painting in 1965 to explore a variety of nontraditional art materials, and to draw ideas from other disciplines, including dance, music, theater, and literature. Despite his love for the sensual properties of paint, his new sense of purpose liberated him to experiment with fiberglass sculptures, performance, video, and light. While making fiberglass forms derived from his paintings, Nauman ventured into light, creating a series of objects (now lost or destroyed) in which he denied the essential qualities of neon and fluorescent tubes by obscuring them with paint, dipping them in oil, or encasing them in fiberglass.

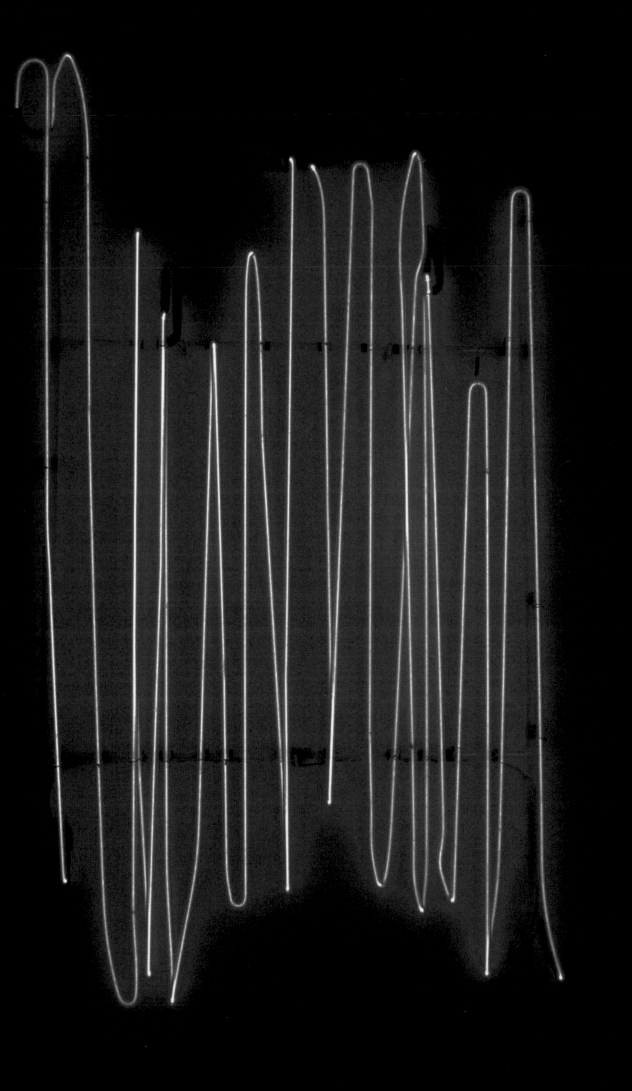

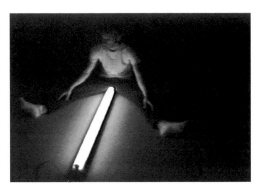

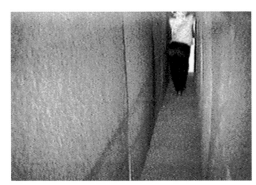

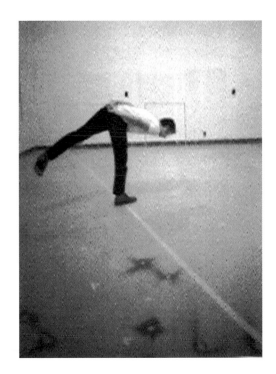

Not satisfied that these works fulfilled his intentions, Nauman conceived a series of performances that probed the role of the artist. In the first, presented as part of his graduating thesis exhibition in 1965, he struck a series of "artistic" poses while incongruously wielding a fluorescent light tube (fig. 8). The artist's own body became his medium and his subject. This led to his first series of light works, beginning with *Neon Templates of the Left Half of My Body, Taken at Ten-Inch Intervals* (1966, fig. 38). These grappled with the body's relationship to identity. The eerie radiation of the green uranium glass presents a surreal abstraction of Nauman's physique. The impression given by his ribs loosely dangling on the wall hovers between that of a menacing visage of a post–nuclear-holocaust corpse and a fragile body that epitomizes our vulnerability.[10]

Nauman progressed from separating portraiture from the person portrayed to divorcing the name from the person named. In the light works *My Last Name Exaggerated 14 Times Vertically* (1967, fig. 7) and *My Name As Though It Were Written on the Surface of the Moon* (1968, fig. 62), he extends the strokes of his signature to the point of pure abstraction. At this time, Nauman was intrigued by Ludwig Wittgenstein's idea that meaning was not shared by an object and its name. Continuing to rebel against the romanticization of art, Nauman ridicules the value placed on an artist's signature by making his own autograph the work of art.

On Rat Diction/Act Indicator

Nauman's *Manipulating a Fluorescent Tube* (1965, fig. 8) spawned a group of performances that investigate a question that preoccupies the artist: "Why is anyone an artist and what do artists do?"[11] It dawned on him that his daily activities in the studio—pacing, drinking coffee, eating—could be formalized into performances that he could videotape and photograph. In *Slow Angle Walk (Beckett Walk)* (1968, fig. 10), the silly walk conducted over an extended period of time is a laborious endurance exercise with absolutely no purpose. It was in part motivated, as the title implies, by similarly absurd actions in Samuel Beckett's writings. Nauman learned that the physical difficulty of controlled movement enhanced his awareness of his body, something he observed in the choreographing of everyday movements in the dance of Meredith Monk and Merce Cunningham. For his *Walk with Contrapposto* (1968, fig. 9), Nauman built a narrow and constraining corridor in which he assumed a parody of the classical figure pose.

7 **My Last Name Exaggerated Fourteen Times Vertically**, 1967. Panza Collection, Massagno, Switzerland

8 Still from the video **Manipulating a Fluorescent Tube**, 1969. Courtesy Electronic Arts Intermix (EAI), New York

9 Still from the video **Walk with Contrapposto**, 1968. Courtesy Electronic Arts Intermix (EAI), New York

10 Still from the video **Slow Angle Walk (Beckett Walk)**, 1968. Courtesy Electronic Arts Intermix (EAI), New York

Nauman understood that Wittgenstein's ideas on language and meaning involved not only linguistic constructs but cultural signs and human behaviors as well.[12] Taking the next logical step, he posed himself the challenge of "how to present this without making a performance, so that somebody else would have the same experience instead of just having to watch me have that experience."[13] Reconstructing the corridor from his *Walk with Contrapposto,* he invited spectators to perform the piece at the Whitney Biennial in 1968 (fig. 12). Nauman's revelation that he could literally engage the audience in his work prompted him to produce a series of illuminated, mirrored, and monitored corridors and rooms in which he could shape perception and behavior.

In these spaces, Nauman conducted a series of experiments in behavioral phenomenology that test the participants' responses to extreme environments as though they were rats in a B. F. Skinner study.[14] He creates situations in which the artist is the omnipotent seer moving chess pieces across the board. In some of his later works, he actually used rats and mice, as in the controlled environments of *Learned Helplessness in Rats* (two versions, 1986 and 1988). In *Mapping the Studio* (2001, fig. 11) he observes nature following its course, with the cat chasing the mice.[15] Referring to *Mapping the Studio,* Nauman reveals something about the scientist-subject metaphor in his corridors and rooms: "There is this obvious predator-prey tension between them."[16]

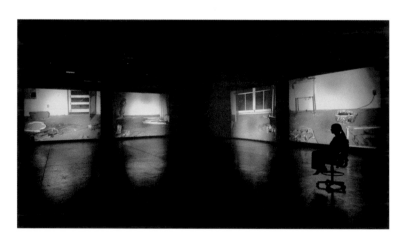

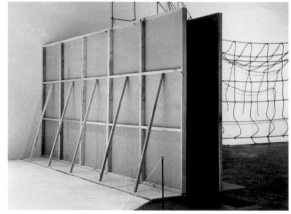

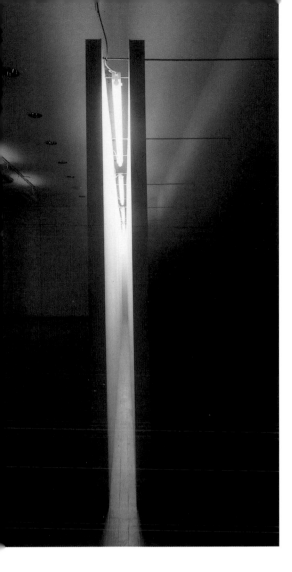

Nauman confessed that the corridor pieces "came out of a dream. It was about being in a long corridor and there was a room at the end of the corridor. The light was a yellow-gray, dim. There was a figure on the left, unidentified. I had the dream many times and I kind of figured it must be a part of myself I hadn't identified."[17] This almost precisely describes the effect of *Corridor with Mirror and White Lights (Corridor with Reflected Image)* (1971, fig. 13). At 7 inches wide, the corridor is too narrow for people to squeeze themselves into. If you were able to enter, you would become claustrophobic, feeling trapped in the tight space. Through the dim light, at the distant end of the oblique corridor you see what might be the figure of Nauman's dream. Only after straining to distinguish the person's features do you realize that it is your own image reflected in a twisted mirror. This mirror fulfills the role of the surveillance cameras in other of his corridors that raise the uneasy question of who is watching you.[18]

While the mirrored and surveillance corridors cause paranoia and uncertainty, the fluorescent rooms overwhelm the senses with stimuli. Their typically oblique walls and destabilizing, bilious light alter the participant's perception of space. This state of overload through deprivation is what Nauman realized to such great effect in the *Helman Gallery Parallelogram* (1971, fig. 15). The artist filled the dealer Joseph Helman's narrow storefront gallery in St. Louis, Missouri, with a parallelogram bathed in acid-green fluorescent light. The skewed walls distort the perception of the room and the bright light melds floor, walls, and ceiling. As a consequence of the retinal barrage, hints of purple—along with blue and pink—enter at the fringes of the visual field. The viewer has to struggle to regain a comprehensible relationship to space. The experience numbs the senses, while simultaneously heightening the understanding of how light and space shape perception.

Because the body's mechanisms for orienting itself are disrupted, it is difficult to remain in the fluorescent light rooms for any length of time. The artist himself admitted that "I could never stay in them." He described the experience as "like being in a liquid at first, so that there was a very strong psychological and physiological response involved."[19] At the same time, the rooms immerse the visitor in a bodily experience of color as extraordinary and transporting as that of a painting made three-dimensional;[20] Nauman concurred that "perhaps it's not so different from a Kelly painting, except for scale."[21] The vitality of Nauman's light rooms resides in this subtle paradox of disorienting anxiety and transcendent beauty.

On Art Diction/Can't It Croon

Nauman believes that "language is a very powerful tool," in fact the most important vehicle for communicating in contemporary society.[22] Working in his studio in San Francisco while teaching at the San Francisco Art Institute, his thoughts were absorbed by the question of how to make a statement about language and meaning without resorting to the trappings of art. An old beer sign hanging in the window of his studio (a converted grocery store) triggered the idea for a dynamic new medium in which to embed language. For his first sign, Nauman painted

11 **Mapping the Studio I (Fat Chance John Cage)**, 2001. From the installation at Dia Center for the Arts, New York, 2002. Collection Lannan Foundation

12 **Performance Corridor**, 1969. Solomon R. Guggenheim Museum, New York, Panza Collection

13 **Corridor with Mirror and White Lights (Corridor with Reflected Image)**, 1971. Tate Gallery, London

the words "the true artist is an amazing luminous fountain" on a sheet of transparent Mylar (1966, fig. 14). The artist again spoofed the romantic stereotype of the artist-creator he had caricaturized in one of his earlier performance works, *Self-Portrait as a Fountain* (1966), in which he mocks the traditional academic subject "la source" as the fountain of artistic inspiration.

But Nauman was not entirely satisfied with the effect of the Mylar piece and turned to neon, hiring a craftsman the next year to fabricate *The True Artist Helps the World by Revealing Mystic Truths (Window or Wall Sign)* (1967, fig. 1). Hanging the sign in his studio window, he announced to the world the grandiose and noble ambitions of his artistic efforts. Or did he? Nauman's strategies are never so obvious. Part of his obfuscation was to hang the sign in his window facing outward, so that visitors to the studio had to decipher the words backwards. During a studio visit at this time, he answered evasively when asked point-blank if he believed the message: "I don't know; I think that we should leave that open."[23] Is he being ironic or sincere? It is revealing that when he was making intensely political works fifteen years later, he admitted that "for me it is still a very strong thought."[24]

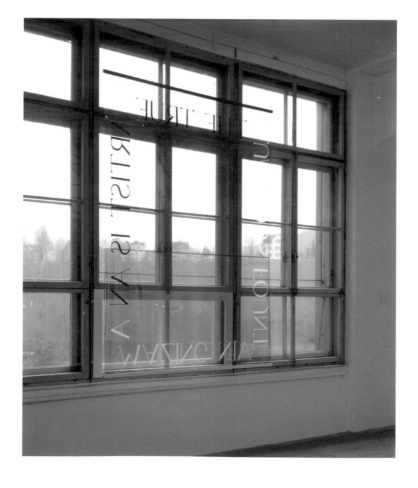

14 **The True Artist Is an Amazing Luminous Fountain (Window or Wall Shade)**, 1966. Raussmüller Collection

15 **Helman Gallery Parallelogram**, 1971. Friedrich Christian Flick Collection

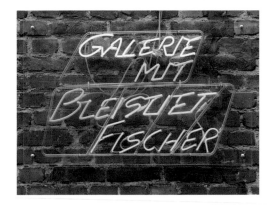

Nauman liked the incongruity of appropriating the format of the commercial sign and presenting it in a gallery or museum. In these institutional settings, the viewer tends to pay attention to the message of individual works, as opposed to the street, where people often ignore the plethora of visual stimuli. He was very aware of how language changed when inserted into the art context and was careful how he used it. Text art proliferated during the heady days of conceptual art in the 1960s and '70s. Nauman was uneasy with straightforward language pieces that read like short stories or novels:[25] "The place where it communicates best and most easily is also the place where language is the least interesting and emotionally involving…. I think the point where language starts to break down as a useful tool for communication is the same edge where poetry or art occurs."[26] Nauman negotiated this edge in a series of word games in neon in which he rearranged letters and phrases to create new expressions. The artist's manipulations of words and phrases deftly navigate the murky waters between language and meaning.

A Jelly Roll Morton song inspired Nauman to create his first neon word game, *Suite Substitute* (1968), and a subsequent variation, *Sweet, Suite, Substitute* (1968, fig. 16). The sequence of words, with its dexterous consonance and homonyms, creates a lyrical rhythm when vocalized. The artist attributes his interest in word games to a variety of literary sources, especially Wittgenstein's *Philosophical Investigations* (New York, 1953), which delves into the structure of language, as well as the writing of Beckett, Vladimir Nabakov, and Alain Robbe-Grillet.

Nauman did not fully explore word games until 1970, when he conceived a series of neon signs based on anagrams, palindromes, and puns. *None Sing Neon Sign* (1970, fig. 17) is a play on words appropriate to his neon text pieces over the next four years. With a self-deprecating, contradictory sense of humor, the artist rearranged the letters of his medium, the "neon sign," to downplay the seriousness of his endeavor. He is being disingenuous when he puns that "none sing" in these neon signs. On the contrary, such pieces as *Raw War* (1970, fig. 63), *Eat/Death* (1972, fig. 18), and *Run from Fear, Fun from Rear* (1972, fig. 61) sing like a chorus, offering provocative commentary on the human condition. *Raw War* passionately decries the compulsion to combat by screaming the word "war" backwards and forwards in red neon. On the other hand, Nauman inverted the letters in a graffiti tag that he saw—"run from fear"— to form "fun from rear," a humorous observation, with sexual overtones, on the instinct to flee rather than fight. Nauman's word games playfully twist expressions and distort logic to create poignant phrases with serious implications. It is as if the opposing drives towards creation and destruction that Sigmund Freud saw as the crux of the human condition had been filtered through the dream logic of a children's nursery rhyme.

16 **Sweet, Suite, Substitute**, 1968. Corcoran Gallery of Art, Washington, D.C.

17 **None Sing Neon Sign**, 1970. Solomon R. Guggenheim Museum, New York, Panza Collection

18 **Eat/Death**, 1972. Collection Angela Westwater, New York

19 **Galerie mit Bleistift Fischer**, 1980. Courtesy Galerie Konrad Fischer, Düsseldorf

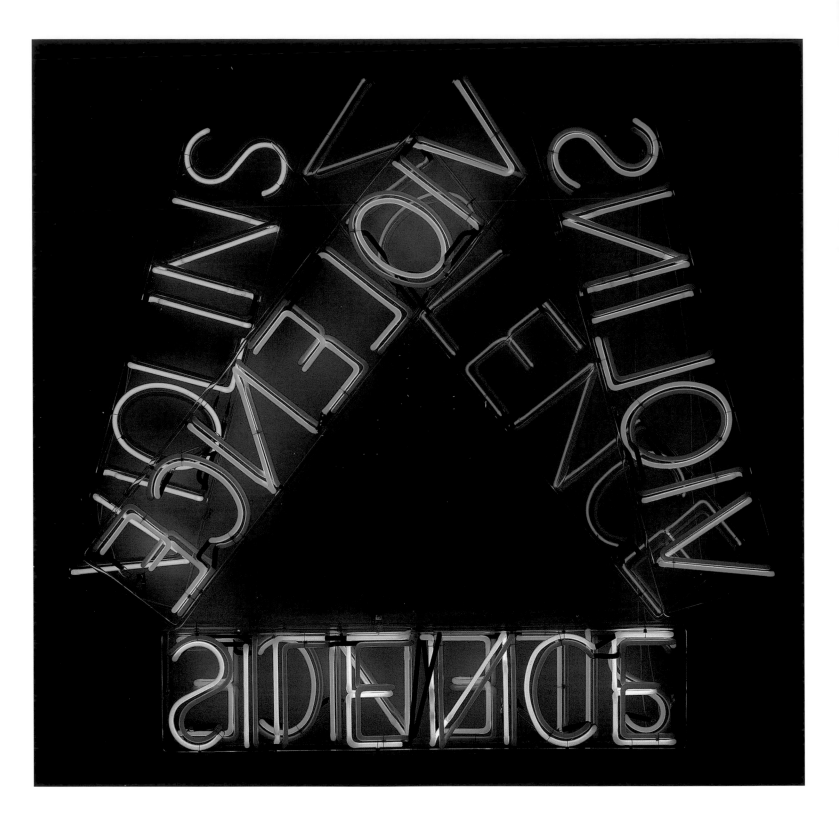

20 **Violins Violence Silence**, 1981–82. Camille O. Hoffmann Collection, Chicago

21 **Violins Violence Silence** (Exterior Version), 1981–82. The Baltimore Museum of Art, gift of Leo Castelli Gallery, New York, and Sperone Westwater Fischer Gallery, New York

For the next six years Nauman did not create any neons, focusing instead on drawing, printmaking, and sculpture. Then, beginning in 1980, he had an intense outburst of production in neon, creating nearly fifty works over five years. During this incredibly prolific period, he created word games, sentences in complex patterns, and figurative neons. The works focus on the human predicament and its opposites of sex and violence, humor and horror, life and death. In 1974 Nauman designed a neon sign for the Konrad Fischer's Galerie in Düsseldorf, though he did not fabricate it until 1980 *(Galerie mit Bleistift Fischer,* fig. 19). At about the same time, responding to reports of human rights abuses in Central and South America, and in South Africa, the artist produced another protest piece in neon, *Malice* (1980, fig. 65). These works catalyzed a surge of neon production unprecedented in Nauman's career.

Among the first of these is *Violins Violence Silence* (1981–82, figs. 20-21), which, when spoken, sounds the beautiful rhyming of three words that convey dramatically different meanings. The word *violin* conjures up a pure musical sound that is squelched by *violence* and obliterated by the succeeding *silence.* The confluence of these words creates an ekphrastic sound poem in visual form that speaks of the extremes of music and silence, creativity and violence. The piece originated as an architectural commission for the music department building at California State University, Long Beach. Nauman's proposal was declined by the university, but the work was later installed on the exterior of the Baltimore Museum of Art at the time of the institution's neon exhibition in 1983 (fig. 21). He subsequently created the version for indoor display (fig. 20) that superimposed the phrase in two layers arranged to form a triangle. The formal simplicity and linguistic eloquence of this neon veil Nauman's cry of disgust over the violence that humans inflict on one another.

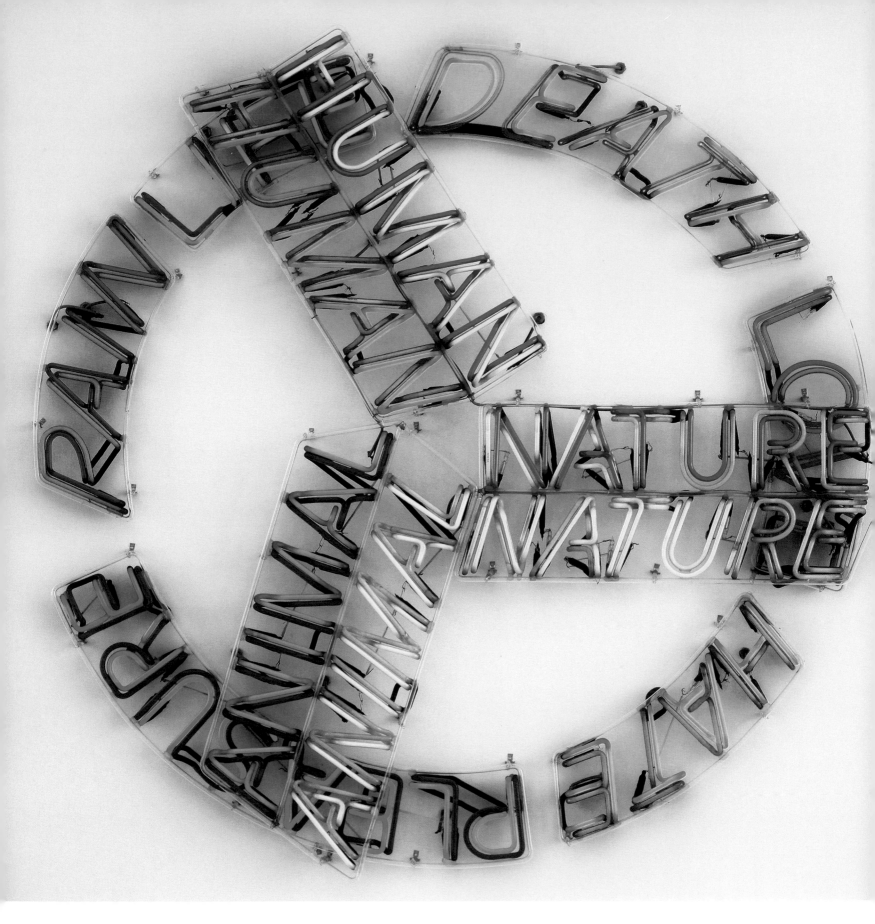

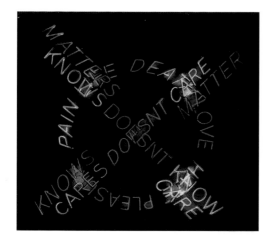

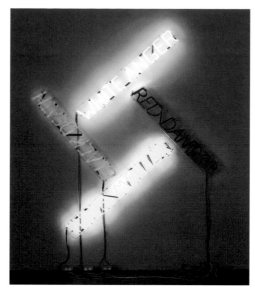

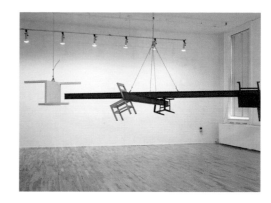

Nauman's neons of this period are more complex in form, language structure, and content than the neons of the 1970s, as he expanded the range of his linguistic games and the technical possibilities of the medium. In 1983 he created a series based on the circle of life and the poles of experience, *Life, Death, Love, Hate, Pleasure, Pain* (1983, fig. 2). In some, he superimposed fatalistic phrases of resignation that "human nature" is equivalent to "animal nature" (fig. 22) and that the confused state of existence is one that vacillates between knowing and not knowing (fig. 23). By layering phrases in complex patterns and employing more advanced switching mechanisms, the artist was able to create dynamic sculptures that invade the surrounding space and demand the viewer's attention.

Both the form and content of the neons of this phase carry covert political commentary. Nauman derived the triangle of *Violins Violence Silence,* the circle of *Life, Death, Love, Hate, Pleasure, Pain,* and the square of *White Anger, Red Danger, Yellow Peril, Black Death* (1985, fig. 24) from sculptural work he had created during the previous years, in which he suspended the simple geometric shapes circumscribed by nineteenth-century physicist Jean-Bernard-Leon Foucault's pendulum. The artist developed these forms into symbols of the global sites where totalitarian regimes exacted torture and genocide on its populations.[27] With unusual directness, Nauman commented that "the implied violence and anger is what the newest work, the triangles and squares, is trying to show and for the first time it's really much more obvious."[28] The neon *White Anger, Red Danger, Yellow Peril, Black Death* is related to a suspended sculpture of the same title (fig. 25). Nauman reconstructed the Christological cross of the steel sculpture into a square neon turned on its point to resemble a swastika. With this formal adjustment, the artist metaphorically pins the devastating racism of the twentieth century on religion and fascism.

22 **Human Nature/Life Death**, 1983. The Art Institute of Chicago, City of Chicago Public Art Program Collection, through prior gifts of Florence S. McCormick and Emily Crane Chadbourne

23 **Life Death/Knows Doesn't Know**, 1983. Mr. and Mrs. Donald Fisher

24 **White Anger, Red Danger, Yellow Peril, Black Death**, 1985. Marieluise Hessel Collection on permanent loan to the Center for Curatorial Studies, Bard College, Annandale-on-Hudson, New York

25 **White Anger, Red Danger, Yellow Peril, Black Death**, 1984. Gift of Werner and Elaine Dannheisser. The Museum of Modern Art, New York

Nauman's output of this period, both the neons and the sculptures, is the most overtly political art he has created. However, he doubts the efficacy of art as an agent of social change: "I don't think I know any good art, very, very, little good art that has any direct political or social impact on culture."[29] The angry invectives shouted in abrasive light express his general frustration with human behavior rather than his response to specific events. He believes that "art ought to have a moral value,"[30] reflecting a humanism that pervades his art.

Nauman's most ambitious neon is *One Hundred Live and Die* (1984, fig. 5). Executed at the scale of a commercial billboard, the work couples a litany of verbs pairing basic human acts with the core facts of existence—life and death. This is the artist's consummate statement on human experience. The piece dominates your visual field and aggressively broadcasts factual, humorous, and vulgar expressions that remind you with imperative directness that *you* "Eat and Die," *you* "Eat and Live."[31] Nauman has mastered common speech to communicate the key questions of life. The combination of vernacular language and crude humor has been dismissed by detractors as "jejune wordplay."[32] But the plain English masks the profundity of the artist's messages. He sequences the entries in his dictionary of life to flash, at times, logical pairs— "Speak and Die," "Speak and Live"—and at others, dissonant couplings—"Scream and Live," "Smile and Die." Finally, they all illuminate in a horrifying blaze, screaming the immutability of our existence. The confusion of order, chaos, and dramatic denouement mirrors the course of human experience.

Cartoon Indict/On Ironic Art

In 1985 Nauman once again defied expectations by introducing a body of figurative neons at Donald Young's gallery in Chicago. The dealer reported that "people were surprised," and he was initially unable to sell the work.[33] Imagine walking into a room to discover a number of electric clowns engaged in frenetic activities that are at once funny and disturbing. The clowns slap each other, pick their noses, shake hands with their penises rising and falling, march in goosestep, and dangle at the end of a noose. The activity more closely resembles Beckett's Theater of the Absurd or Antonin Artaud's Theater of Cruelty than a traditional circus or theater performance. Nauman commented: "I got interested in the idea of the clown first of all because there is a mask, and it becomes an abstracted idea of a person.... Because clowns are abstract in some sense, they become very disconcerting.... When you think about vaudeville clowns or circus clowns, there is a lot of cruelty and meanness. You couldn't get away with that without makeup."[34]

The idea of personifying violence arose for the artist from the implied violence of his own suspended chairs, triangles, and squares.[35] The sculptures evolved into the figurative work, resulting in seventeen neons fabricated over the course of a single year (1985). Through the clowns Nauman conveyed an existential view of humanity, contrasting the themes found in the earlier text pieces—life and death, humor and horror, and sex and violence.

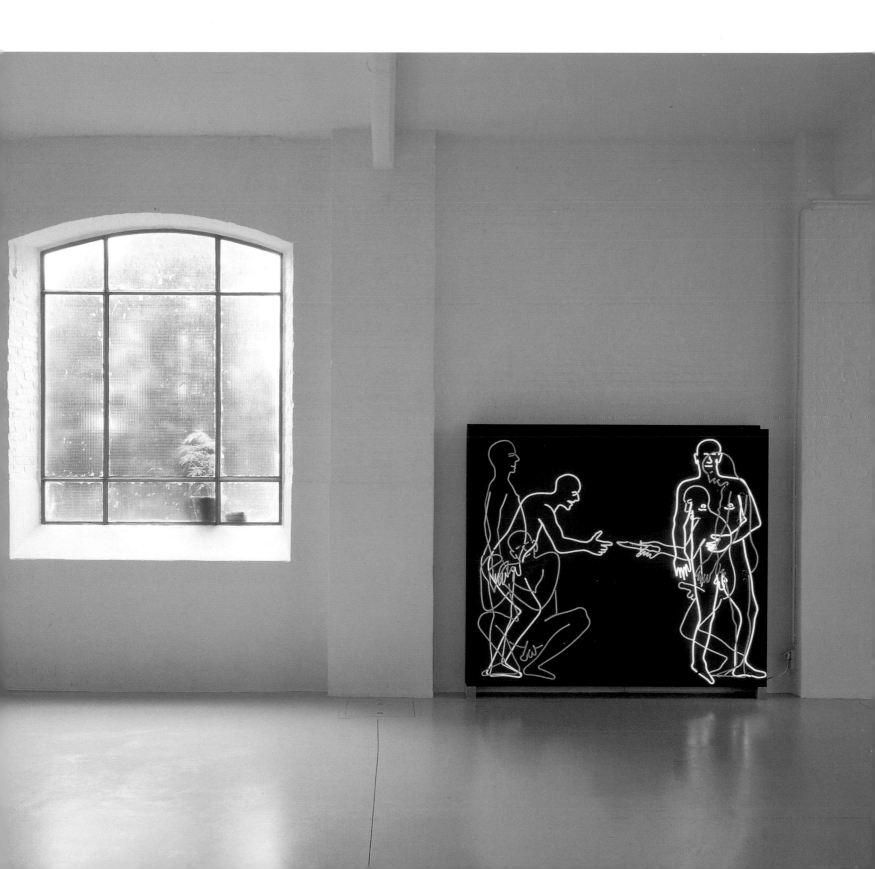

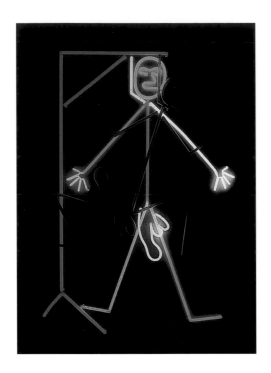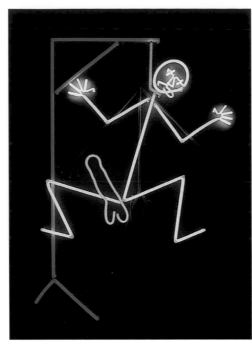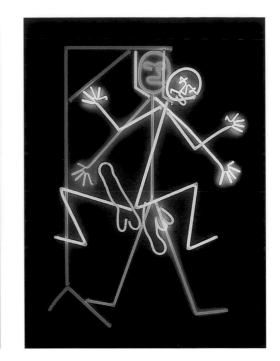

Among Nauman's first ventures into figurative neons is *Mean Clown Welcome* (1985, fig. 56). A clown with an erect penis extends his hand to another, who reaches out to receive the greeting, which is withdrawn at the last second. Because they are clowns, this is funny. At the same time, the mean and puerile joke offers a sad commentary on the alienation of people. Nauman enhances the alternation of humor and horror by manipulating the cycle and colors of the neon: "With the figure neons, the timing sequence is very important—it becomes violent. The pace and repetition make it hard to see the figures, and although the figures are literally engaged in violent acts, the colors are pretty—so the confusion and dichotomy of what is going on are important, too."[36]

The clown's mask hides his identity, leading some to suggest that the figure is not simply an anonymous theatrical entertainer, but the artist's alter ego.[37] Who is the perpetrator of these jokes, after all? Who is it who has claimed that he enjoys setting up unresolved expectations and misleading the viewer? Who is it that disguises himself behind the mask of the clown? The clown is the artist himself. As he confessed in an interview, "I think it has to do with a personal fear of exposing myself."[38]

The format of the joke-that-turns-violent and the clown-as-artist links the emergence of the figurative neons with the revival of video in Nauman's work. After creating numerous performance videos early in his career, the artist abandoned the medium for fifteen years, and then resumed with a series that continues to the present. Videos such as *Good Boy, Bad Boy* (1985, Electronic Arts Intermix, New York) and *Violent Incident* (1986, fig. 28) center on jokes that turn nasty, in the manner of the figurative neons. In one case, *Good Boy, Bad Boy,* Nauman

transformed the video into a neon (1986). In the new videos the artist does not film himself performing, but hides behind actors he engages to speak for him. As with the neons, he uses these videos to confront the contradictions in behavior and manifest his disturbing sense of humor in themes of sex and violence.

Sex has been the dominant subject of the figurative neons since the first example, *Big Welcome* (1985). In this double-sided piece, Nauman introduced two of the principal motifs of his figurative neons: the hand extending in greeting on the recto and the penis rising and falling on the verso. Half of his figurative neons are devoted to clowns with active penises and people masturbating or engaging in sex.[39] These neons are far removed from a sensual display of sexuality. Rather, the artist presents sex as a self-indulgent activity bordering on the absurd by rapidly repeating actions like masturbation ad nauseum. Nauman links sex with cruelty and the abuse of power, a theme that culminates in *Sex and Death* (1985, fig. 26), in which the artist equates erect penises with the guns and knives of the deviant clowns who are about to kill one another.

Nauman also used figurative neons to explore two subjects prominent in his text pieces— political commentary and language games. In *Five Marching Men* (1985, fig. 29) he graphically ridicules militarism—as he did in earlier works such as *Raw War* (1970, fig. 63)—by presenting a profile of five men marching in an awkward goosestep, their penises choreographed to rise and fall with their legs. Consumed with word games, Nauman presented this obsession figuratively with his *Hanged Man* (1985, fig. 27): "When I take the game, I take it out of context and apply it to moral or political situations.... For instance, the Hanged Man neon piece (1985) derives from the children's spelling game.... You finally lose the game if you complete the figure—if you hang the man.... Then I added the bit about having an erection or ejaculation when you're hanged. I really don't know if it's a myth or not."[40] Embracing opposites, the artist relished the notion of using a children's game as a metaphor for the horror of violence.

Following this extraordinary flurry of figurative work in 1985, Nauman essentially ceased making neons. He fabricated a few text pieces, including the monumental text version of *Good Boy, Bad Boy* (1986–87) and one figurative neon, *Diver* (1988, fig. 31), but these were derived from previous works (*Hanged Man* in the case of *Diver*). His installation of *Vices and Virtues* on a laboratory building at the University of California, San Diego (1988, fig. 30), was taken from designs dating to 1983. Nauman created a number of sculptural installations that were strikingly lit, such as *Black Marble Under Yellow Light* (1981/1988), but this too derived from earlier drawings and the light was used primarily to illuminate the marble stones, not to affect perception and body awareness as in the earlier environments. The last neon he intended to create was suggested by Konrad Fischer and based on the text "Partial Truth." However, Fischer died before the piece was fabricated. Nauman instead produced a multiple as a memorial to the dealer, who had shown an enduring commitment to his work from the beginning of his career.[41]

27 **Hanged Man**, 1985. Museum of Contemporary Art, Chicago, Gerald S. Elliott Collection

28 **Violent Incident**, 1986. Tate Gallery, London

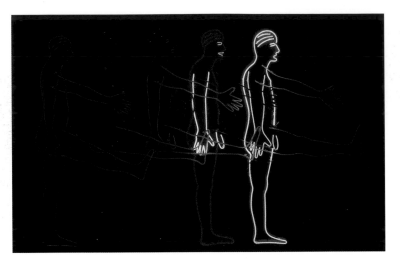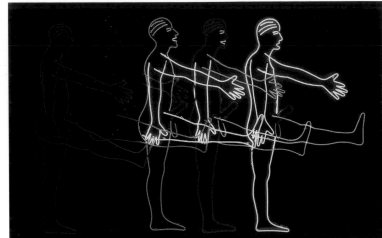

Five Marching Men, 1985. Friedrich Christian Flick Collection

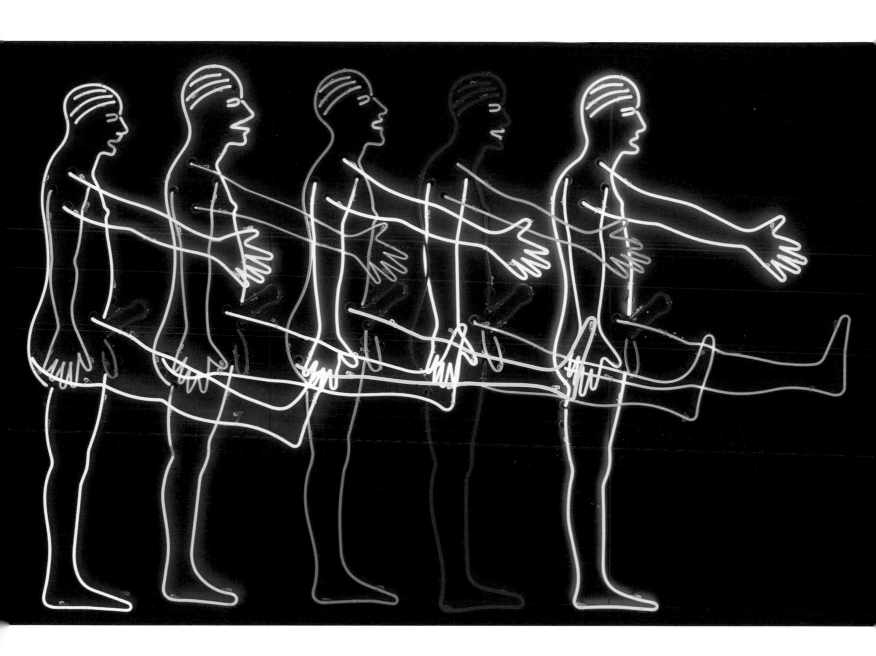

Why did Nauman stop working with light? The reason is as explicable as any of the inconsistencies throughout his art. He burned through the medium in the early 1980s, then a change in his thinking necessitated a change of mode of expression and he began to focus on video and sculpture. In discussing his turn away from neons during the late 1970s, Nauman remarked that "I still get tired of working on one idea, in one medium for too extended a period and, in that sense, I divert myself by moving to something else."[42] The same motivation applied when he stopped making neons in the mid-1980s. Observing the path of some of his colleagues and peers, he wanted to avoid stagnation: "It seems important to see a number of people just disappear or slide or get to a point and just stay there, and it seems important to consider how to continue to be an artist over a long period of time—to keep the work interesting to yourself. You know, you have no interest in doing the same work over and over again."[43] Once again, Nauman's thinking returned to his core questions: What is the purpose of artists and what do they do?

30 **Vices and Virtues**, 1983–88. Stuart Collection, University of California, San Diego

31 **Diver**, 1988. W. Vanhaerents, Torhout, Belgium

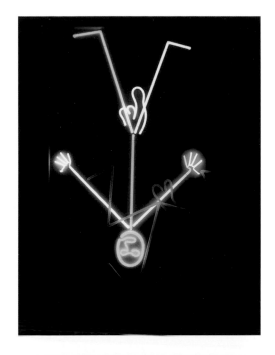

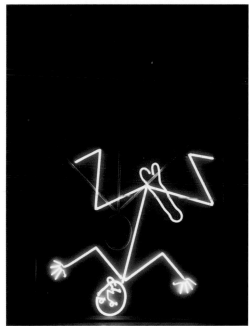

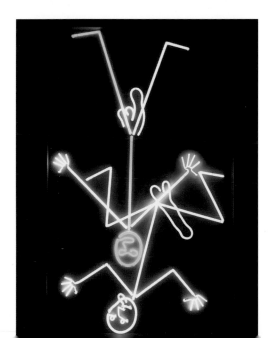

Art Condition/Art Con Icon

Beginning in graduate school, Nauman demonstrated a profound curiosity about the function of art and the artist. Some critics have misinterpreted this preoccupation to suggest that his art is only about art.[44] On the contrary, Nauman's art is about ideas; it is not a narcissistic self-indulgence directed at the cognoscenti. He has unequivocally stated that "I really mistrust art that's just about art."[45] He founded his approach on the belief that the chief means of conveying ideas in contemporary society is language, which he interprets broadly to include cultural signs that shape our thoughts and behavior.

By creating word games, controlled environments, and figurative metaphors, Nauman generated innovative art forms and new ideas about art. In each of his pieces he assaults the viewer with his mantra, "think think think." His approach is intentionally abrasive, offensive, and disturbing. The meanings in his works are often ambiguous and contradictory. He has us consider portraiture in relation to our identity by modeling his rib cage in neon or exaggerating his name to the point of illegibility. He conducts experiments on us in his rattrap corridors and rooms, testing the limits of our perception and behavior. The artist's playful language games leave us amused, but confused. His figurative and text neons catalogue the horror of violence, sexual perversity, abusive power, and the finality of death. These are difficult issues, but ones that every sentient person confronts.

With wit and pungency, Nauman tackles these fundamental subjects. He advocates a moral basis for art, establishing a strong humanistic foundation for his work. But he does not take an evangelical position on morality: "My work comes out of being frustrated about the human condition. And about how people refuse to understand other people. And about how people can be cruel to each other. It's not that I think I can change that, but it's just such a frustrating part of human history."[46] In a review of Nauman's 1994 retrospective organized by Walker Art Center, one writer criticized the artist: "Rather than failing to idealize, [he] seems to idealize failure."[47] Perhaps Nauman would accept this criticism as a compliment since, as in Beckett's writings, failure seems to be one stratagem for survival. Indeed, his assault on our sensibility is a cry of outrage at our inability to fulfill our moral obligation to one another. His ploy to thrust our inherent contradictions in our faces with the ludic force of language sways our thoughts and responses dizzily between the competing extremes of the psyche. The result is like a Rosetta Stone to a modern world gone terribly awry. Certainly these are the conclusions I draw from a focused examination of Bruce Nauman's elusive signs.

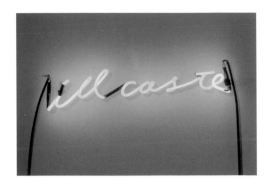

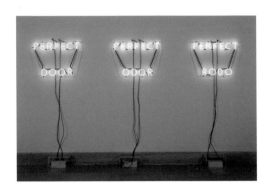

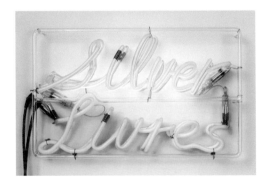

32 **Ill Caste**, 1972. Leo Castelli Collection, New York

33 **Perfect Door/Perfect Odor/Perfect Rodo**, 1972.
Dallas Museum of Art, General Acquisitions Fund,
The 500, Inc., Dorace M. Fichtenbaum, Mrs. Edward
W. Rose III, an anonymous donor, the Friends
of Contemporary Art and a matching grant from
the National Endowment for the Arts in honor
of Sue Graze

34 **Silver Livres**, 1974. Ealan Wingate, New York

35 **Triangle Room**, 1978/1980. Solomon R. Guggenheim
Museum, New York, Panza Collection

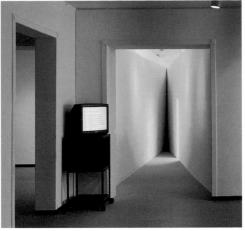

36 **Left Standing, Standing or Left Standing**,
 1971/1999. Collection Lannan Foundation,
 long-term loan to Dia Art Foundation, New York

37 **Pink and Yellow Light Corridor (Variable Lights)**,
 1972. Solomon R. Guggenheim Museum, New York,
 Panza Collection

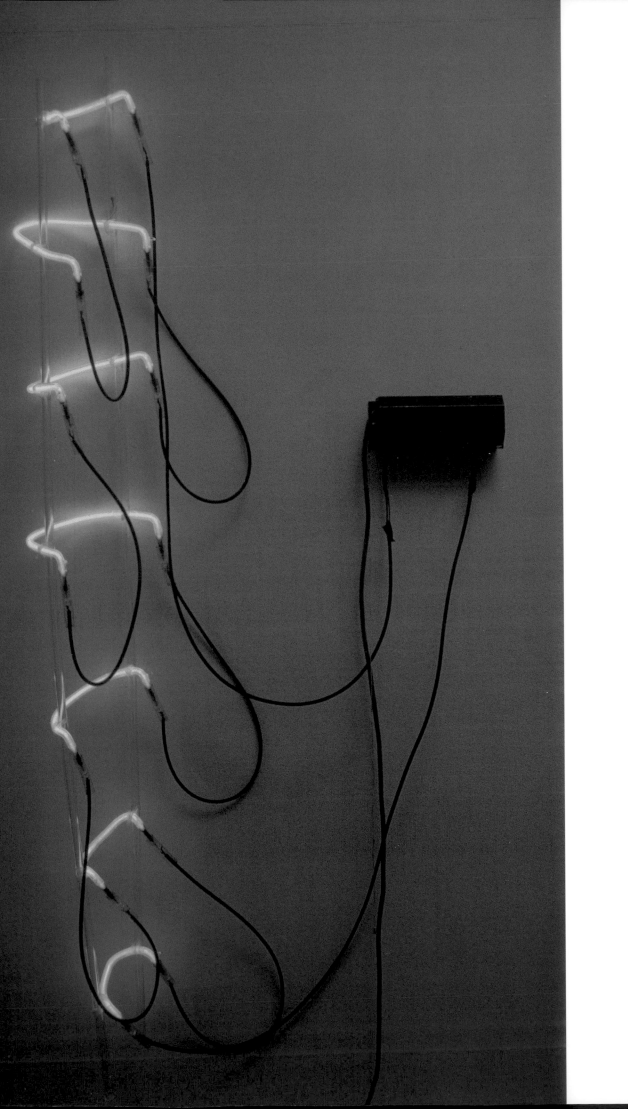

SIGNS AND·SYSTEMS
On Nauman's Neon Templates and Other Works

JANET KRAYNAK

Templates

Neon Templates of the Left Half of My Body Taken at Ten-Inch Intervals (1966, fig. 38). Consider, for a minute, the strangeness of this sculpture. At first glance, we see what appears to be a mechanical apparatus, replete with wires, tubes, and plugs, and not the soft edges of bodily form. Physical volumes are forsaken for an open grid comprised of seven neon tubes, each one forming a perfect little arch. Vertically stacked one on top of the other, the tubes form a line suspended from a translucent frame, fabricated from lengths of clear glass tubing. Emerging from the ends of each curved neon piece is a series of black electrical cords, which playfully loop down from the central form, providing the work with its source of illumination. The entire contraption is then hung on the wall: the place, conventionally, of painting, and not of sculpture, and also of commercial advertising (an observation to which I will return later). In the dissonance of its parts, *Neon Templates* is fundamentally enigmatic. Given that the body referred to in the title has been rendered utterly unrecognizable, the work forces the question: What is the subject of this sculpture?

Long considered a significant, even iconic, example of Bruce Nauman's early, unorthodox work, the sculpture nonetheless is remarkable for its eccentric approach to materials, technique, as well as to its subject (or subjects, as this essay will suggest). In art-historical terms, moreover, *Neon Templates* marks a specific moment in Nauman's artistic development and, in a larger context, broader changes in art in the aftermath of minimalism. By figuring the beholder as a physical, perceptual being, rather than simply a set of eyes, minimalism paved the way for the literal incorporation of the artist's body as a sculptural material or source: a development that became increasingly prevalent in the late sixties and early seventies, in the work of artists as diverse as Vito Acconci, Adrian Piper, and Carolee Schneeman, among many others. In Nauman's practice of the mid-to-late sixties, we see evidence of this bodiliness in many

38 **Neon Templates of the Left Half of My Body Taken at Ten-Inch Intervals**, 1966. Estate of Philip Johnson, courtesy of the National Trust for Historic Preservation

places: in recorded performance actions, audio pieces, photographs, molded and cast sculptures, and architectural installations. In these examples, the body becomes a tool, a reference point, a mold, an instrument for producing sound. In *Neon Templates,* this bodily engagement seems most explicit and direct: the sculpture, as proposed in the title, represents an actual physical imprint of the artist's left side, marking and measuring his own body.

As such, *Neon Templates* seems to be exemplary of "body art," which emerged in the late '60s and in which the physical, psychological, and physiological aspects of the body were explored.[1] For some commentators, body art stresses the putative *authenticity* of the body, leading to an implicit, or in some cases explicit, link between "the body" and "the real." As Kristine Stiles writes, "The body is the medium of the Real, however multifarious that Real becomes and is manifest."[2] For others, the direct use of the artist's own body renders body art an inherently subjective and personal medium and, as such, its meanings largely autobiographical.[3] It is tempting thus to conclude that *Neon Templates,* with its tangible connection and seemingly intimate proximity to the artist's body, operates as a surrogate "self-portrait," in line with the artist's other works, such as *Self-Portrait as Fountain* (1966).

Yet the literal mechanics of the sculpture—tubes of neon, electrical cords, a black transformer plugged into an outlet on the wall—are oddly incommensurate with this subject or, at the very least, suggest other concerns are operative as well. First is the fundamentally technological origin of the medium of neon itself: an industrial material with the unavoidably commercial overtones of advertising signage. A reference to neon as a medium of commercial exchange is more explicitly made in Nauman's contemporaneous neon sign piece, *The True Artist Helps the World by Revealing Mystic Truths* (1967, fig. 1). Inspired by a beer sign hanging in his studio window—a remnant of the space's previous life as a storefront—Nauman produced his own "advertisement," a tongue-in-cheek statement about the conventional status and power of the artist. In short, neon is a material that bears insistently contemporary connotations, pointing to the proliferation of media and advertising in the mid-'60s: a transformed cultural landscape of "signs."[4]

In addition, consider the sculpture's formal structure. Rather than an image or even a holistic or seamless imprint, we get a fragmented, abstracted series of parts, made from hollow, curved pieces of neon. The body is not so much represented as reduced and quantified, broken down into a series of seven units. Each neon fragment, moreover, constitutes a unit of measure, providing the sculpture with its underlying conceptual logic. These measured parts are then explicitly identified as "templates." Now, a template is, according to a common definition, a pattern or guide for making *something else:* theoretically, it should be used over and over, yielding multiple, related manifestations. A template only exists to repeat a form or image;

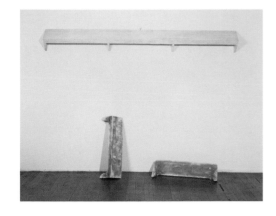

39 **Shelf Sinking into the Wall with Copper-Painted Plaster Casts of the Spaces Underneath**, 1966. Froehlich Collection, Stuttgart

thus it inherently implies a serialized or reiterative dynamic. The question ensues, how does this structure square with the ostensible subject of the sculpture—that is, the artist's body, a supposedly unique, subjective reality?

In this essay, the implications of these and other aspects informing Nauman's *Neon Templates* will be investigated. The aim, however, is not simply to provide an interpretation of one object; rather, by using the sculpture as a foil—a "template," if you will—I intend to illuminate significant aspects of Nauman's practice in general, and how it embodies, in sometimes unconventional ways, important shifts in artmaking of the '60s. The significance goes beyond artistic developments, however, pointing to broader socio-cultural conditions that both frame and inform Nauman's art.

Signs

If one simply looks at *Neon Templates,* it is not so obvious that it bears any relationship to Nauman's body, let alone *any* body, at all. Fundamentally, it is an abstracted object. Indeed, the only means the viewer has to access what the sculpture supposedly represents is its title: a statement (putatively) of fact, that these are templates generated from the curved edges of the artist's left side ankles, hips, waist, and so on. Without such contextual information to fill in its perceptual gaps, the work is largely unreadable as form. As such, Nauman's *Neon Templates* elaborates a central Duchampian premise: namely, that the object of art does not in and of itself—that is, ontologically—confer meaning, or rather it is always already dependent on something supposedly outside of, but actually integral to its form: namely, language. Specifically, in the case of Duchamp's readymades, language takes the form of the declarative statement identifying the found object as "art"; and in Nauman's *Neon Templates,* it manifests itself in the work's lengthy, descriptive title.

In a statement referring to the *Neon Templates,* in fact, the artist himself explicitly mentioned its title. Rather than an afterthought or supplement to the visual and physical qualities of the sculpture, the title, Nauman insisted, was indispensable to the work. Queried about the shift from his earlier untitled fiberglass sculptures, which consisted of abstracted, elongated shapes, to works such as *Neon Templates,* which specifically identify or name things, he remarked: "Now I wasn't just making shapes to look at, by saying that 'these are templates of my body', I gave them reason enough for their existence."[5] In a similar vein, speaking of *Shelf Sinking into the Wall with Copper-Painted Plaster Casts of the Spaces Underneath* (1966, fig. 39), a sculpture consisting of visually ambiguous shapes or forms, but whose title directly connects it to the external world of concrete things, the artist once commented that "the elaborate title enables you to show a mold with its casts without presenting the work as such."[6]

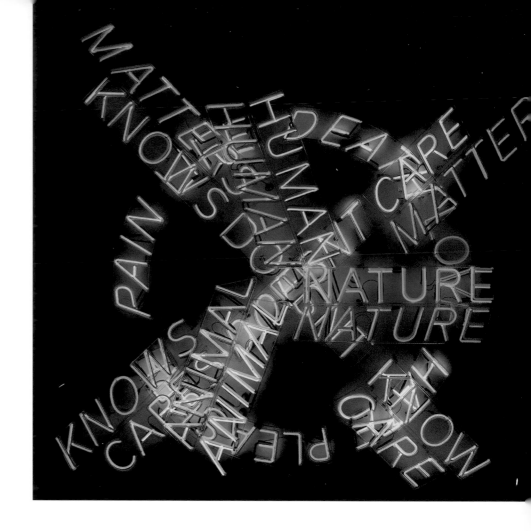

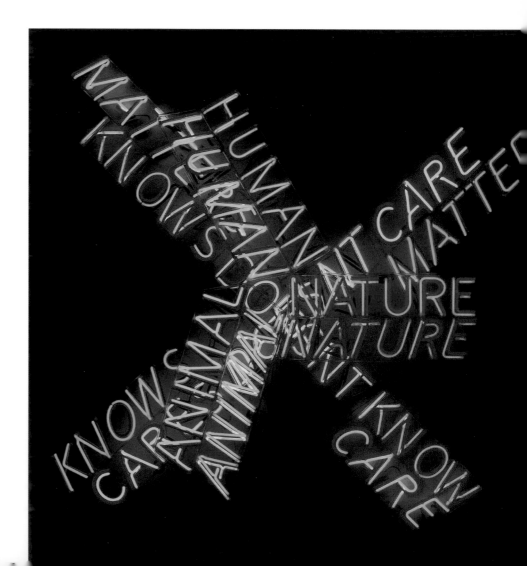

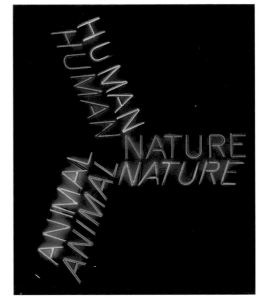

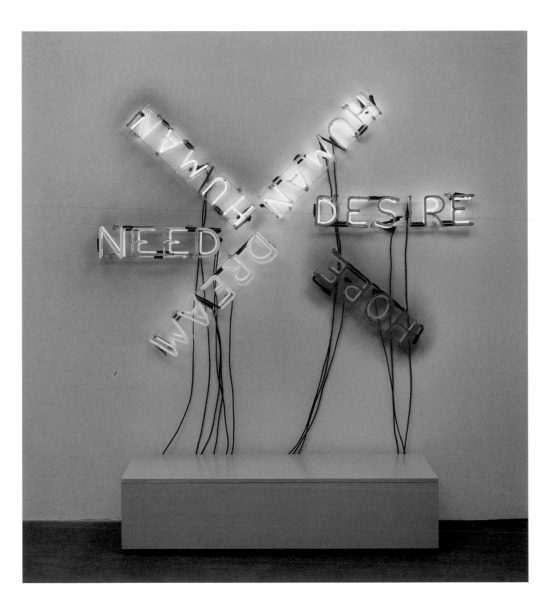

42 **Human Nature**, 1983. Collection of Martin Z. Margulies, Miami

43 **Human/Need/Desire**, 1983. The Museum of Modern Art, New York, gift of Emily and Jerry Spiegel

Other examples can also be cited: there is *Wax Impressions of the Knees of Five Famous Artists* (1966), a horizontal sculpture that sits laterally on the floor and is marked by a series of indentations. In an accompanying drawing (fig. 44), potential candidates for the "five famous artists," the source of these impressions, some of whom are long deceased, are provided: the inscription reads, "Assign each knee print an identity—preferably of some (moderately) well known contemporary artists—(perhaps some / historical artist who has not been dead over 100 years?) / (Do not use Marcel Duchamp) / William T. Wiley / Larry Bell / Lucas Samaras / Leland Bell." Nauman concludes with a caveat: "Or / perhaps all 'knee prints' / should be the same image but titled as above." The artist speaks of this work in the following: "Making the impressions of the knees in a wax block was a way of having a large rectangular solid with marks in it. I didn't want to just make marks in it, so I had to follow another kind of reasoning. It also had to do with trying to make the thing itself less important to look at. That is, you had to know what it is about, too."[7]

Nauman's comments are casual but revealing, implying that the titles, if not outright deceptions, at the very least bear a questionable relationship to the truth. Listen carefully to the qualifications Nauman provides: "*By saying* 'these are templates of my body', I gave them reason enough for their existence"; "the *elaborate title enabled me* to show a mold with its casts without presenting the work as such"; "*assign* each knee print an identity"; "*I had to follow another kind of reasoning.*" Indeed, these latter statements refer to the *Wax Impressions of the Knees of Five Famous Artists*: a sculpture that is composed not of wax, but fiberglass, and does not bear knee impressions of "five famous artists," but only of Nauman's own. As the artist states explicitly, "I was interested in the idea of lying, or not telling the truth. The full title is *Cast in Wax,* or *Molded in Wax,* or something like that—but it's a fiberglass piece."[8]

In tandem with the visual evidence of the works themselves, Nauman's words direct us not to take the titles at face value. In fact, their lengthy, almost cumbersome nature threatens to produce more confusion than clarity, in that the detailed information they deliver frequently fails to cohere or "add up" when one then turns to the object that it accompanies—and purportedly identifies. A synapse between the perceptual and conceptual information ensues, resulting, paradoxically, in their inextricable coupling. In other words, the descriptive information becomes internalized to the extent that we cannot see the visually ambiguous, even abstract, sculpture *other* than as shapes deriving from the artist's body, despite the initial sense of estrangement they produce. The implications of this dynamic relationship between objects and language is significant: Nauman's extensive use of descriptive titles (what he once called "functional titles"[9]) is evidence of a complex engagement with language itself—or, more specifically, the nature of linguistic signs.

In linguistic theory, a sign is the basic unit of the semiotic system, the individual element that, in relation to other signs, forms a language. According to Ferdinand de Saussure, a Swiss

linguist whose theories of the early twentieth century have been central to modern semiotics, the sign bears an *arbitrary* relationship to its referent (or the "real" object to which the sign refers). For example, the word "apple," a set of five letters placed in a particular order, has nothing to do with the red fruit that grows on trees. It is only by convention, not necessity or any "natural" affinity, that we associate the two. In *Wax Impressions*, the arbitrary nature of the sign comes into play most explicitly, in that the words are appended to a thing to which they actually bear no relation. In *Neon Templates*, a similar possibility remains: that is, that a series of neon sections—formal shapes—are randomly, arbitrarily assigned a referent after the fact.

The body at issue in the *Neon Templates*, we might say, is the body as *sign*. More precisely, *Neon Templates* interrogates not the nature of the physical body, but the operations of the linguistic sign. Here, we can turn for guidance to another important founder of modern semiotics, Charles S. Peirce. According to Peirce, there are three general types of signs: *symbol* (such as a word), which is related to its referent via convention; *icon*, which, as the name implies, is related by resemblance (such as the little trashcan picture on a Macintosh desktop); and *index*, which bears a direct physical or causal relationship to its referent (such as a footprint in the sand). During the period in which Nauman made the *Neon Templates*, an exploration of the indexical sign abounds in his work. There is *Wax Impressions of the Knees of Five Famous Artists*, with its knee imprints; *Collection of Various Flexible Materials Separated by Layers of Grease with Holes the Size of My Waist and Wrists* (1966, fig. 45), a horizontal floor sculpture made from the layering of thin sheets of assorted materials pressed into a rectangular stack, which is then punctured by three different-sized holes; *Platform Made Up of the Space Between Two Rectilinear Boxes on the Floor*, an index of negative space, now given positive form through casting; and *Neon Templates*, with its curved sections of neon: indices of bodily measure.

44 **Untitled (Study after "Wax Impressions of the Knees of Five Famous Artists")**, 1966. Emanuel Hoffmann Foundation, permanent loan to the Öffentliche Kunstsammlung Basel

45 **Collection of Various Flexible Materials Separated by Layers of Grease with Holes the Size of My Waist and Wrists**, 1966. Helen Acheson Bequest (by exchange) and gift of Douglas S. Cramer, The Museum of Modern Art, New York

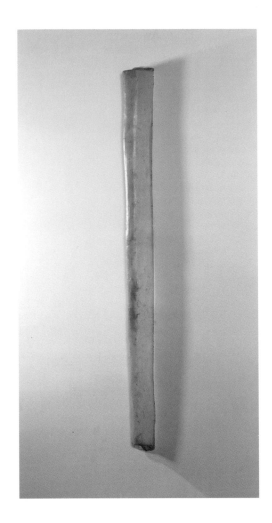

Nauman's interest in the nature of the index is not unique, but is part of more general developments in postwar art. For example, there are the sculptures and paintings of Jasper Johns, as well as Robert Morris's preminimalist objects, both of which represent significant precedents for Nauman's own work, as well as mediators in a postwar re-examination of the experimental practices of Duchamp.[10] But as art historian Rosalind Krauss argued in a pair of important essays from 1976–77, across the seeming heterogeneity of '70s art—"video; performance; body art; conceptual art; photo-realism in painting and an associated hyper-realism in sculpture; story art; monumental abstract sculpture (earthworks); abstract painting"—there is an extraordinary unity, but one found not on the level of "style" (the traditional art-historical classification), but through an exploration of the index, or "the way that it operates to substitute the registration of sheer physical presence for the more highly articulated language of aesthetic conventions."[11] For Krauss, this indexical turn is consequential, indicative of a shift in the very nature of representation itself, one she characterizes in terms of a burgeoning postmodernist ethos, in which a photographic logic displaces the pictorial orientation of modernism.[12]

While this indexical turn is indeed relevant to our understanding of Nauman's sculptures—as in each instance, "abstract" objects are reduced "to the status of a mould or impression or trace," to cite Krauss[13]—the role of language in his art goes beyond a semiotic understanding. As mentioned above, the "functional titles," to borrow Nauman's words, are integral elements in the very conception of the physical sculptures. Nauman's characterization—"functional"—is useful in that it emphasizes the pragmatic dimensions of language: that is, referring not simply to the character of the linguistic sign and its role within a self-contained linguistic system, but also to the nature of linguistic activity that emerges in lived experience. As beings in the world, we "use" language to negotiate our daily reality; rather than a passive repository of ideas, already formed in the mind of a speaker and then unchanged on delivery, language is a dynamic, dialogical medium.[14] To give an example: above I mentioned the estrangement the viewer experiences in beholding Nauman's *Neon Templates*—and similarly, one could look to a number of other examples, such as his *Six Inches of My Knee Extended to Six Feet* (1967, fig. 46), a sculpture consisting of an elongated, abstracted form. Produced through the intentional distortion of a body part, the sculpture yields a sense of defamiliarization: a gap between its physical dimensions/visual qualities and the experience of our own bodies. Here, language is not simply descriptive, but operates as an interactive medium—a relay point between speakers, in which the reception of the information is as significant in the construction of meaning as its delivery. In this performative model of language, linguistic rationality, or "sense," potentially breaks down, resulting in miscommunication, misunderstanding, or misrecognition. Rather than "flaws," such aspects are inherent to linguistic activity.[15] In other words, language is a messy, material reality with many afterlives.

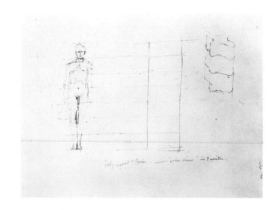

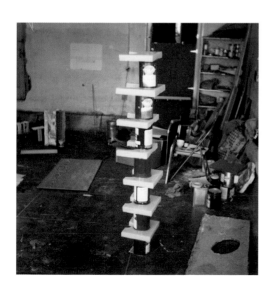

Repetitions

Preliminarily, we can conclude that among the multiple "subjects" of Nauman's *Neon Templates* is one that is perhaps not so obvious: the operations of linguistic signs and the nature of linguistic activity. This interpretation is based, in part, on considering seriously the function of the sculpture's title, in addition to the formal means with which ideas are embodied. What still needs to be addressed, however, is another central aspect of the title mentioned in the beginning of this essay: namely, the notion of the template. As noted above, a "template," according to common understanding, is a pattern or mold: that is, something used in the production of something else, and which should be employed in numerous instances. In one sense, a template can be thought of as a mechanism for and of repetition. And indeed, the *Neon Templates* is not an autonomous object, but is one of a series of related works, all of which are based on the measured body template.

Between 1966 and 1967 Nauman made a number of other template pieces. There is *Wax Templates of the Left Half of My Body Separated by Cans of Grease* (ca. 1967, fig. 48), a free-standing column made up of a series of flat, U-shaped plates that are stacked alternately with gallon-size cans of grease. The work—since destroyed by the artist—is pictured in a 1967 photograph of the interior of Nauman's San Francisco studio (in which several other works can also be seen, including *Collection of Various Flexible Materials Separated by Layers of Grease with Holes the Size of My Waist and Wrists* [1966, fig. 45], and the neon sign *The True Artist Helps the World by Revealing Mystic Truths* [1967, fig. 1]). The second related sculpture is *Plaster Cast Based on Neon Templates* (1966), which is essentially the inverse of the *Neon Templates*: Using the hollow templates as a mold, Nauman crafted an elongated, tubular object, which was then colored with bronze-tinted paint. Last, and perhaps most significantly, is a series of ten drawings, all made between 1966 and 1967 (in other words, some before and some after the completion of the neon sculpture). The drawings function both as autonomous works, and also as a framework within which the particularities of the *Neon Templates* can be illuminated.

One of these drawings, made in 1966 (fig. 47), is a figurative sketch of a human body, depicted frontally, with a series of parallel lines dividing it laterally into seven equal parts. The size of these sections, according to the sketch and the artist's notations, is determined by the measure of the head. On the bottom of the drawing Nauman has written: "Body is about 7 heads—make 'space (divide)' in 7 units." The human form is envisioned as a series of relational units, based on a single body part acting as module. On the right side of the sketch, above the grid, Nauman has drawn a stack of ovoid shapes with protruding sides; this odd form is not identified but seems to correspond to a cross-section of the body as if viewed from above, with the head protruding beyond the oval area of the shoulders. This cross-section seems to represent the positive form Nauman employed to make the "indexical" templates that comprise the *Wax* and *Neon Templates* sculptures. In the former, the punctured plates are then stacked vertically,

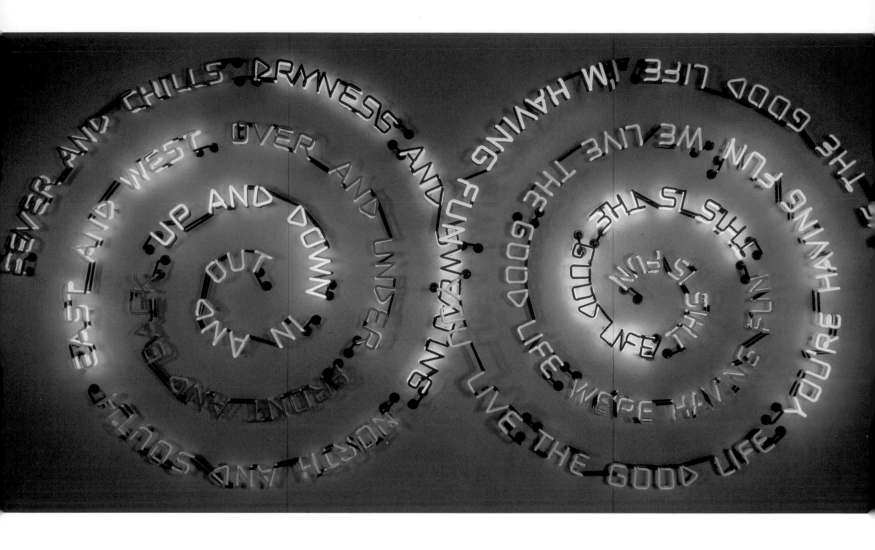

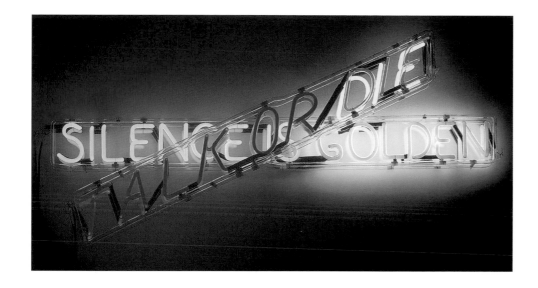

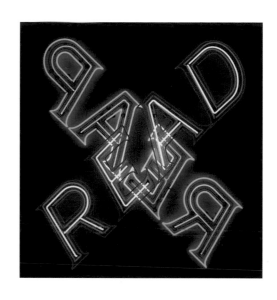

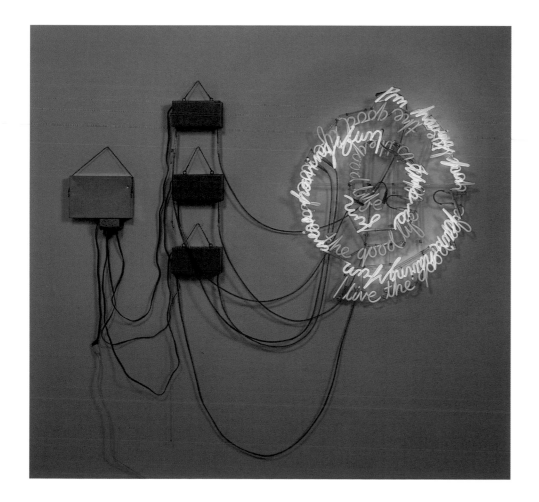

49 **Having Fun/Good Life, Symptoms**, 1985.
Carnegie Museum of Art, Pittsburgh, purchase:
Gift of the Partners of Reed Smith Shaw and McClay
and Carnegie International Acquisitions Fund

50 **Silence Is Golden/Talk or Die**, 1983. Donna and
Howard Stone, Chicago

51 **Read Reap**, 1986. J. P. Morgan Chase Art Collection

52 **This Is Fun/This Is the Good Life**, 1985.
San Francisco Museum of Modern Art, purchased
through a gift of Dr. and Mrs. Allan Roos

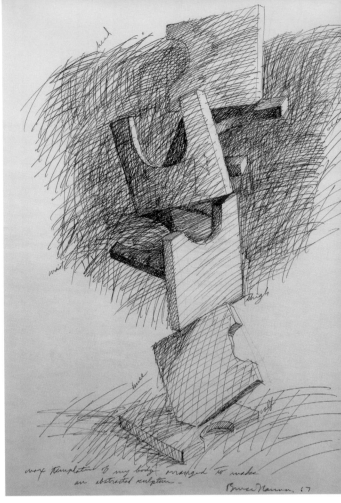

with seven grease cans serving as a surrogate "heads" separating each layer, while in the latter, the arcs of neon tubing enclosing negative space are separated at 10-inch integers, again representing the "ideal" measurement of the head.

What the drawing reveals is that a specific reference for—or, more accurately, origin of—Nauman's sculptures and drawings derives from the history of art: namely, the theory of human proportions. An academic exercise developed in order to uncover the divine or natural order—believed to be mathematically quantifiable—underlying the organic human form, the theory of human proportions originated in antiquity, but was used and modified throughout the history of Western art. In this system, the body is broken down into a series of mathematically related parts, yielding a set of norms or conventions that could be applied in the artistic representation of human subjects. As historian Erwin Panofsky wrote, far from a mere objective, mathematical principle, however, the theory of human proportions reveals the *Kunstwollen* (roughly translated, the "artistic will") of each age.[16] Starting with the Byzantine era, for example, the dimensions of the body were expressed solely through the module of the head or face, whereas prior to this period, other body parts were equally employed. But "now the face, the seat of spiritual expression, is taken as the unit of measurement," Panofsky declared.[17] Although used in different periods of Western art, the theory of proportions is most closely identified with the Italian Renaissance, where, as Panofsky comments, it rose to the status of a "metaphysical postulate." During this time, beauty was defined as proportional harmony. Art aspired to scientific exactitude, and science viewed artistic works as embodiments of universal

truths. With the theory of proportions, the body was broken down or reduced to a series of parts—ideal measurements that produced an ideal standard of beauty—but only insofar as they could be seamlessly reintegrated, as the integrity of the human body was paramount.

The question arises, why this reference in Nauman's works to an admittedly archaic artistic convention? Moreover, one that was deployed in the service of illusionism—that is, the convincing translation of the three-dimensional world onto a two-dimensional plane—a historically obsolete imperative that is certainly not the preoccupation of Nauman's generation of experimental artists. In Nauman's drawings, the systematicity of measuring or codifying the body is everywhere apparent—seven units are consistently used—but regularity is sacrificed for an almost comic sense of play. The drawings demonstrate the templates in every possible permutation: lying on the floor; stacked one on top of the other; suspended from the wall like so many Donald Judd minimalist boxes, rendered imperfect through the indexical bodily excisions that are carved into the geometric forms. Rather than maintaining any proper order, Nauman's drawings rearrange the templates into seemingly endless imaginative combinations. In one example (1967, fig. 54), the templates are upended and then stacked vertically, appearing to tumble like a fragile structure built out of a deck of cards. Nauman inscribes the drawing on the bottom: "Head / shoulder / chest / waist / thigh / knee / calf / wax templates of my body arranged to make an abstract sculpture." In these drawings, the fundamental mechanism of the theory of proportions is deployed as a building block, but put to a purpose that has little to do with the tradition of figurative representation from which it originally emerged.

Systems

In discussing *Neon Templates* (as well as *The True Artist Helps the World by Revealing Mystic Truths*), Nauman once made the following observation: "I was trying to figure out how you make something without having to invent, pretend to invent, the formal system—circles, squares and spirals. And then also go into parts of the body, going back to those templets [*sic*] and things like that—that was the old standard drawing proportional system, where the head was supposed to be one seventh of the body. And so I just divided the body into the same parts and made those templates, using these devices to kind of make reasons."[18] Like the formal geometries ("circles, squares, and spirals"), the "old standard drawing proportional system" provided a readymade device: an a priori mechanism that can be used and reused in the service of making. As such, the true originary—or originating—source for the *Neon Templates* and related works is not Nauman's body, but a preexisting formal system that can be deployed in the production of a neon sculpture, a wax sculpture, or a drawing.

Defined as a formal mechanism rather than personal object, the templates precisely subvert subjective input, undermining the presumed link between creation and invention in a way that recalls minimalist sculpture. For the minimalists, techniques of industrial fabrication, and the principles of seriality and repetition—"one thing after another," as Donald Judd famously

53 **Seven Wax Templates of the Left Half of My Body Spread over 12 Feet**, 1967. Emanuel Hoffmann Foundation, permanent loan to the Öffentliche Kunstsammlung, Basel

54 **Wax Template of My Body Arranged to Make an Abstracted Sculpture**, 1967. Washington Art Consortium: Henry Art Gallery, University of Washington, Seattle; Museum of Art, Washington State University, Pullman; Northwest Museum of Arts and Culture, Spokane; Seattle Art Museum; Tacoma Art Museum; Western Gallery, Western Washington University, Bellingham; Whatcom Museum of History and Art, Bellingham

wrote—were a means of eliminating the hand of the artist from the work of art, as well as the perceived subjectivity of compositional decision-making. As such, the art object itself was radically depersonalized and the possibilities of what constitutes it greatly expanded. Similarly, Nauman's *Neon Templates,* with its industrial or technical base and regularized repeating forms, furthers the notions of industrialization, seriality, and repetition so central to minimalist aesthetics. It is, however, a reiteration with a difference. With its dependence on language as an intermediary device and its direct bodily reference, Nauman's sculpture deviates from the abstract perceptual logic of minimalism.[19] But furthermore, the final works reveal the formal schema or mechanism itself: in other words, the sculptures and drawings simultaneously utilize and demonstrate their underlying system of representation. In this way, Nauman's *Templates* shares a logic with an important artistic development of the mid-'60s: systems aesthetics, itself an elaboration of the "serial attitude," to employ Mel Bochner's term, of minimalism.[20]

Systems aesthetics is traditionally associated with conceptual art, in which the art object is defined as an analytical rather than simply visual or perceptual entity. The conceptual object seeks to reflect on its very conditions of production, reception, distribution, and institutional-ization in a manner that renders these "subjects" explicit.[21] In systems aesthetics, as the name itself suggests, the system deployed becomes a central subject of the work, which may now take the form of simply an annotation, without any other material realization. Alternatively, both the notational schema and its execution may comprise the work. In, for example, Sol LeWitt's wall drawing *Lines, not short, not straight, crossing and touching, drawn at random, using four colors (yellow, black, red and blue), uniformly dispersed with maximum density covering the entire surface of the wall* (1971), the detailed instructions outlined in the work's lengthy title are manifested graphically as a wall drawing that enacts the given schema. Or consider Mel Bochner's *36 Photographs and 12 Diagrams,* made in 1966 (the same year as Nauman's *Neon Templates*). In Bochner's photographic work, a series of gridded diagrams, based on mathematical formulas, are depicted in tandem with their application in the form of small sculptures comprised of blocks.[22] Or there is Dan Graham's *Schema (March, 1966)* of the same year. Conceived in the form of a magazine advertisement (and thus explicitly calling attention to its reproducibility), the piece consists of a listing of factual information (that is, the number of adjectives, the type of paper stock, and so forth) related to the publishing context. As such, each permutation will result in an entirely different work, a point Graham emphasizes in subsequent commentary about the work.[23]

While Nauman's *Neon Templates* is clearly distinct from these examples, demonstrating a formal logic and other concerns not found in "systems aesthetics," there is a related conceptual framework that is significant, but is often subsumed when the sculpture is approached solely from the perspective of body art. Namely, the final art object constitutes an elaboration of an underlying mechanism or structure—in this case the proportional template—which is named in its title and functions as an integral component of sculptural materiality and perception.

Like LeWitt's wall drawing described above, *Neon Templates* reiterates a preexisting schema, that is, the theory of human proportions, in which the head operates as a module dividing the body into seven units. In the LeWitt, the wall drawing represents one instance or enactment of a plan, which essentially constitutes the primary object. Nauman's *Neon Templates* similarly eschews the authenticity of the singular, material object, but on slightly different terms. First, to push the rhetorical analogy of the template, the *Neon Templates* is both complete and partial: an autonomous thing in and of itself, but one that expresses a set of principles that can be simultaneously realized in other forms, such as drawings. And second, as with all of his neons, Nauman regularly authorizes reproductions of the work—exhibition copies. In other words, the locus of the artwork is found in the plan, the notational schema, or idea, which can be realized as convincingly as the "original" in subsequent iterations.[24]

Systems aesthetics and other practices based in notational structures such as Nauman's find echoes in a broad range of experimental art of the sixties: from avant-garde music, which further explored John Cage's reconception of the score and redefinition of musical notation to "new dance," such as the Judson Dance Theater, which introduced the language of choreography—now defined as a form of dance gesture—within the live performance. These developments, however, were not themselves self-contained, but need to be considered within broader socio-cultural developments of the mid- to late '60s. With computerization, the advent of the information age, and an explosion of media culture, a radically new economic and cultural paradigm began to emerge. Whereas prior to this era, traditional forms of production and labor still predominated, now an economy based in technical information and service came into being. One outcome was a proliferation of what philosopher Jean-François Lyotard terms "language technologies": systems theories, information theories, computer languages, cybernetics, and so on.[25] As a result, not only does information become a privileged site (and a commodity), but also potentially everything—experience, the body, politics—can be subject to quantification, codification, and logical analysis. In coming to terms with this new, techno-logically altered reality, many expressed a fear not of technology as an isolated tool, but as an uncontrollable social phenomenon, shaping and transforming reality, while rendering it largely unfamiliar.[26]

It is within this artistic and social context—of signs and systems—that I want to situate Nauman's *Neon Templates*. Here the givenness of the body, its reality, is rendered largely unstable, replaced by the measured body, the body as sign, the body as system. Viewed from this perspective, the sculpture's technical apparatus no longer seems strange or unfamiliar; rather, in neon, the sculpture finds its perfect expression—a template of a time.

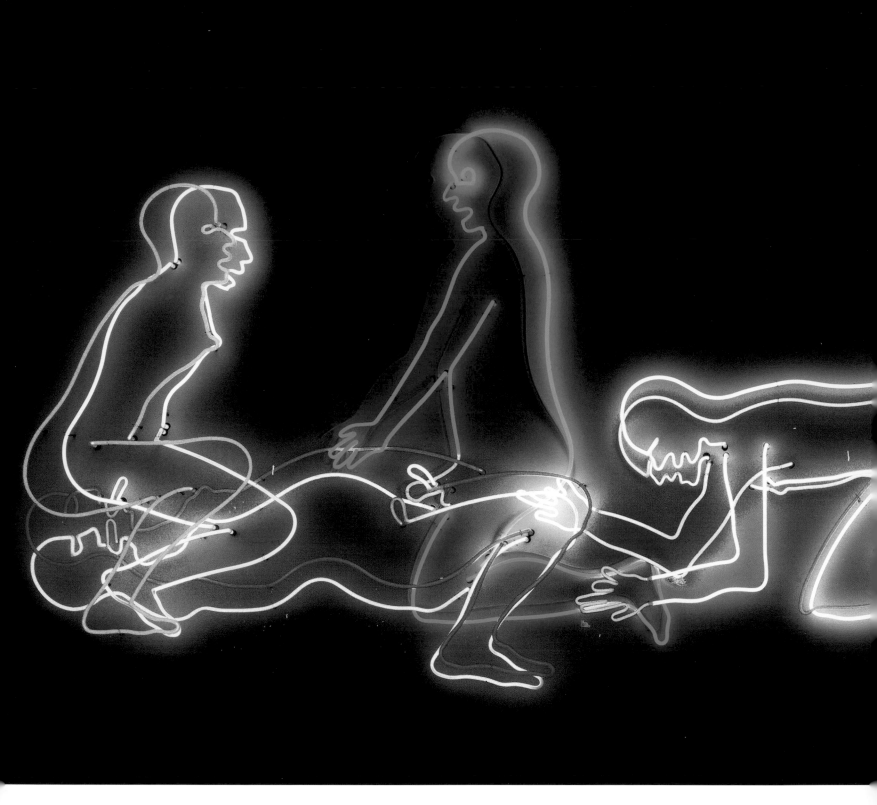

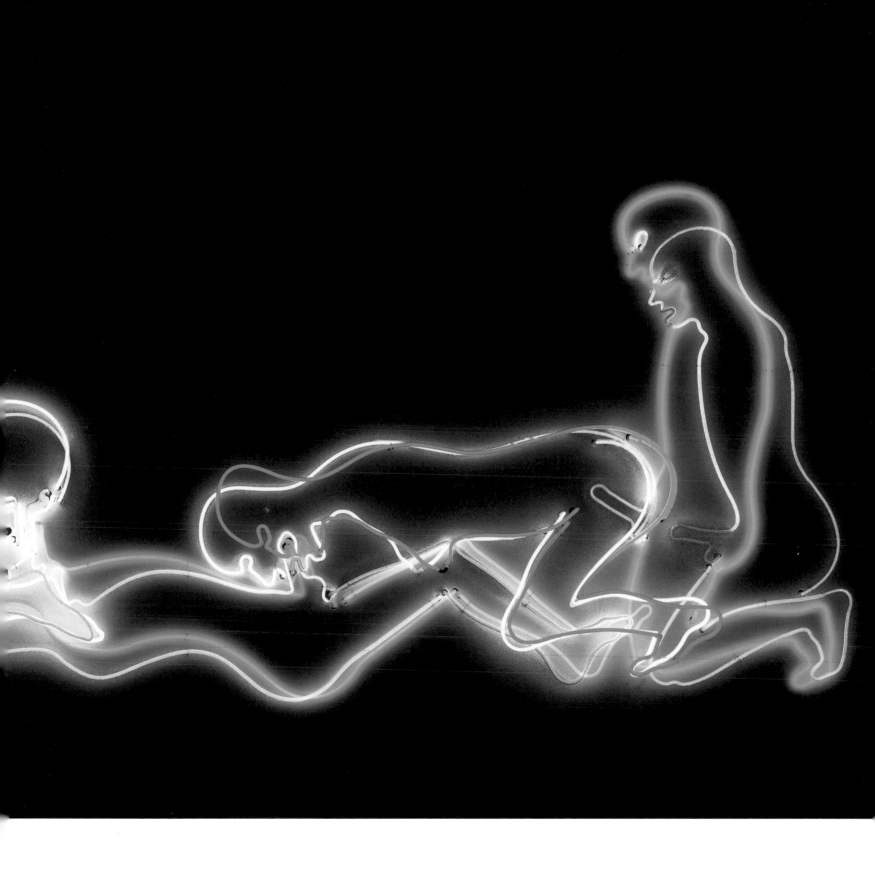

55 **Seven Figures**, 1985. Stedelijk Museum, Amsterdam

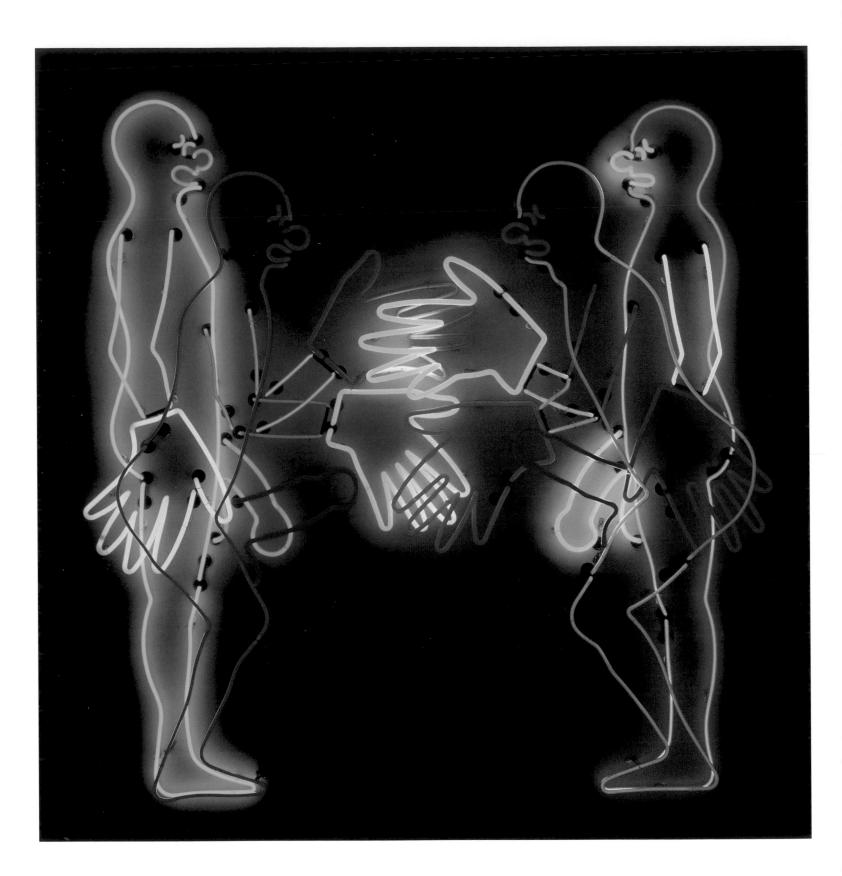

MILES OF STARE The Bruce Nauman Carnival

GREGORY VOLK

1

I'd like to begin by discussing a famously reclusive figure known for verbal dexterity; acute image-making proclivities; a concise, highly innovative aesthetic rife with psychological associations and connotations; and an ability to question and investigate complex ranges of human experience, including wonder and debilitating fear, attraction and repulsion, communion and solitude, liberation and confinement. This figure, for the moment, is not Bruce Nauman, but instead the poet Emily Dickinson.

Like just about everyone else in the Calvinist, semi-rugged, semi-wilderness western Massachusetts Amherst of her day, Dickinson wanted to be a believer: a committed, blissful Christian, a member of the elect (in the parlance of her time). Required for this was an authentic conversion experience in which one truly felt and experienced ecstatic communion with Christ. Dickinson doubted, at times anxiously and at times despairingly, whether she would ever have such an experience. In a famous moment from 1847, when Dickinson was seventeen years old, her classroom teacher, Miss Lyon, summoned the students to a communal zeal, and it was expected that everyone who wanted to be a Christian would stand up. The others stood, but Dickinson remained seated; whether this was out of shyness, contrariness, an already sophisticated Calvinist theology that would preclude insincere or premature protestations of faith, or something else, is anybody's guess.

Later, Dickinson had a lot to write about the experience of wanting to be a believer, but having that desire thwarted, subjected to raw and withering doubt, or suffused in endless ambiguities and contradictions. Among the many poems that she wrote about her lifelong conflict is poem 243, of 1861, in which she compares "a heaven" (namely her kind of a Calvinist heaven, with deep roots in New England Puritan theology) to a small, presumably rinky-dink carnival rattling

across the great expanse of North America, stopping in towns for a brief while to bring a little excitement, and then moving on. Here's how the poem goes:

I've known a Heaven, like a Tent—
To wrap its shining Yards—
Pluck up its stakes, and disappear—
Without the sound of Boards
Or Rip of Nail—Or Carpenter—
But just the miles of Stare—
That signalize a Show's Retreat—
In North America—

No Trace—no Figment of the Thing
That dazzled, Yesterday,
No Ring—no Marvel—
Men, and Feats—
Dissolved as utterly—
As Bird's far Navigation
Discloses just a Hue—
A plash of Oars, a Gaiety—
Then swallowed up, of View.

This poem constitutes a remarkable moment in American poetic (and artistic) history. Here, two Americas are twined: an America of religious vision and another America of spectacle, flashiness, pop culture excitement, and, perhaps, implacable loneliness once the excitement has faded and one is left with one's conflicted self. For the poem's form, Dickinson takes her cue from what was then a pervasive art form in her area—the Protestant hymns that were sung ad infinitum in every church on every Sunday. However, as has often been noted, she subjects the familiar model to an amazing array of transformations. She uses dashes, which break the rhythm and make everything seem a lot more choppy and unsettled. Other subtle, yet jarring, alterations of sound and rhythm create gaps and surprising twists of thought in the poem, and make it seem not a poem about consciousness, but a profound rendition of consciousness altogether, with all its fits and starts, bursts of enthusiasm, and moments of faltering. Rather than relying on standard rhymes, Dickinson uses off-rhymes (boards/yards, disappear/carpenter, stare/America) that fit, but not exactly, and suggest a curious process of cohesion and fissuring: The poem holds together, but it is pulling apart at the same time. Throughout, Dickinson is decisively personal ("I've known a heaven") and implicates herself in some of the largest and most disturbing human questions: an aptitude for faith and the visceral experience of loss and bewilderment; a desire for joy contradicted by sadness and disappointment. Her looming "miles of stare" is an extraordinary image, conjuring not only an outward gaze into great

distances, but also an inward investigation into the tangled depths of the psyche. Moreover, while Dickinson's images are all familiar to the point of banality—a circus tent, boards, nails, a bird or boat on the horizon—they have an evocative power, as well as unusual emotional and psychological depth. And at the center of it all is a strange, but apt, comparison: a vanished heaven and a withdrawing carnival, both of which purport to offer respite from human troubles—one eternally and the other for a night or an afternoon.

2

Later, 106 years later to be exact, in San Francisco, Bruce Nauman placed a neon sign of his own making in his studio window, at a time when he was having his own crisis of artistic faith, questioning how to proceed, how to move beyond his early paintings, and whether it was even remotely possible as a young artist to maintain visionary aspirations. Inspired by a neon beer sign hanging in the window when he moved in, his sign (1967, fig. 1) announced to passersby— and now to museum-goers—in spiraling blue and peach tubes: "The true artist helps the world by revealing mystic truths."

Suddenly your average 1950s–'60s beer sign for Schlitz, Miller, Rheingold, Bud, or Carling's Black Label takes on striking new potential. Instead of hawking a product, it offers what seems at first glance a ringing declaration, but which on second thought is anything but straightforward. For one thing, the sentiment advanced about artmaking is fundamentally moral and religious—access to "mystic truths" in art is something that will "help the world"— but morality and religiosity are not normally associated with neon signs. For another, this is hardly a commonplace assumption about artmaking. Many adequate and at times excellent artists through the years haven't given a hoot for mystic truths, and still managed to produce influential art.

Whether ironically or not, in presenting the "true artist" as seeker and spiritual guide, Nauman taps into a particularly visionary strain of artmaking in this country, which can be traced back to Ralph Waldo Emerson and nineteenth-century transcendentalism. As the Unitarian minister Emerson gravitated from the church to art as the forum for his inquiry, he brought with him a conviction that art (really any kind of art, though poetry was the term he most frequently used) must indeed reveal mystic truths, and must also be imbued with spirit, in order to have, for him, profundity and validity. Emerson made enormous claims for art, seeing it as inseparable from questions of individual character, psychological growth, revelation, and redemption. What he wanted was an art of radical self-discovery coupled with radical openness to the world— a world understood to be suffused with God, the Over-Soul, Unity, or Beauty (Emerson used many different terms for this divine essence). Emerson's spiritualized approach to artmaking, which involved discovering exalted possibilities in humdrum materials and situations, and which mixed a cerebral philosophizing with emotionalism, immediately affected luminist painters like Fitz Hugh Lane and Martin Johnson Heade, various Hudson River school painters,

and poet Walt Whitman, who noted, "I was simmering, simmering, simmering: Emerson brought me to a boil." Long after transcendentalism ended, Emerson's questing approach intersected with quite a number of artists, including painters such as Edward Hopper, Mark Rothko, Barnett Newman, and Agnes Martin; California "light and space" artists such as Robert Irwin and James Turrell; and practitioners of land art like Robert Smithson and Michael Heizer. While there is nothing romantic about Bruce Nauman's work, its essential elements suggest he might be considerably closer to Emerson's ideal than one would normally suppose: his focus on core-level matters of what it means to be a human being; his interest in art as a cathartic and transformative force; his mix of cerebral investigation and hard-hitting emotions; and his consistent ability to find fresh, oftentimes highly unorthodox methods for delving into his concerns.

In any event, depending on one's perspective, Nauman's matter-of-fact rendition of an Emersonian pronouncement is either right on the mark (albeit really weird in neon), completely ironic, flat-out wrong, or partly plausible, and probably an amalgamation of all of these. There is a great deal of slippage going on, and these physicalized words begin to seem fragile and unstable, as fragile and unstable, in fact, as the materials from which they are made—thin glass tubes and illuminated gas. It is also impossible to determine where Nauman himself comes down on the issue. We are left guessing whether he believes this message, or does not, or both believes it and disbelieves it simultaneously; whether it is all high seriousness or instead a big joke. One thing Nauman's sign certainly does is to persuade the viewer to question her or his basic assumptions and responses, including suppositions about the actual meaning of these words and the degree of moral authority the artist has (or doesn't have). Moreover, while the sign has roots in a beer ad, the use of pure light—long a symbol for spiritual invigoration—fits with its message, as does the spiraling, totemic shape. In the meantime, all sorts of strange collisions are occurring: beer signs and mystic truths, Vegas colors and soulful depths, consumerist seduction and spiritual aspirations. In explicating her own crisis of religious faith, Emily Dickinson turned to a traveling carnival for her imagery. The young Bruce Nauman, in his typically contradictory and inscrutable way, dealt with a crisis of artistic faith by turning to gaudy neon signs, which also have their carnivalesque attraction.

3

In reviewing the critical literature, it becomes apparent that the work of the elusive Nauman has been approached in many ways through the years. He has been seen as an analyzer and deconstructor of language, influenced by Ludwig Wittgenstein and the French "new novelist" Alain Robbe-Grillet. Some read him as a caustic provocateur engaged in social and political critique. He has been considered a postminimalist sculptor, a post-sculpture conceptualist, a pioneering video artist, a minimalist performance artist, and an infiltrator of pop culture. While all of these interpretations are in some measure accurate, Nauman evades, and in all likelihood will continue to evade, all attempts to sum him up, precisely because he is such an eccentric

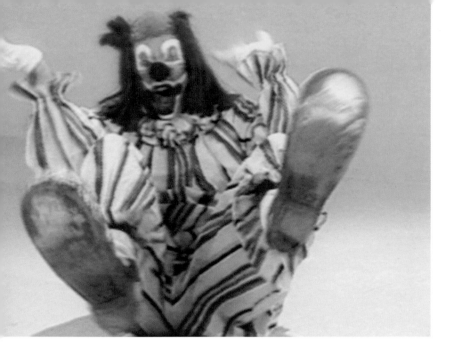

self-inventor, dealing humorously with serious matters, seriously with humorous matters. He makes a seemingly impersonal art that appears to be charged with profound issues of self, and does so in many different mediums, from video and performance to sculpture, photography, drawing, language, and neon signs.

Still, it seems to me that there is another way of approaching Nauman altogether, which has to do with carnivals, circuses, amusement parks, cheesy roadside attractions, and carnivalesque signage. Far more than any other major American artist who emerged in the fruitful years of the mid-1960s to the early 1970s (with the possible exception of Vito Acconci), Nauman is predisposed to circus gear and carnival tropes, and this in a country both celebrated and notorious for its P. T. Barnums, Coney Islands, Frontier Towns, Great Adventures, state fairs, and Disney extravaganzas. What's particularly compelling is how Nauman transforms these vehicles of entertainment and escapism into arenas of tense psychological, social, sexual, and political inquiry, often coupled with both dark and slapstick humor.

Nauman has, for instance, featured clowns, notably in his famous video installation *Clown Torture* (1987, fig. 57), in which four videos show the performers in various (and excruciating) conditions of frustration, abasement, and punishment. He has also featured mimes, hand puppets, and masks, and he has covered his upper body and face with theatrical make-up, becoming, in turn, white, pink, green, and black. He has made precise, but ungainly and too-narrow corridors in different versions, which elicit a vaguely House-of-Horrors anxiety shading into claustrophobic terror (as in an actual House of Horror, you see what's right before you, you know that it is a contrived environment that you're entering only temporarily, but still the emotions and the psychic disruption are authentic and disturbing). He has made two variations on the suspended room, one illuminated from within and the other dark with the light outside; they are disconcerting and fear-inducing as well as contemplative and inviting—you can half-imagine a grizzled carny in the foreground collecting tickets and intoning, "Step right up!" Nauman has appeared in garish, red holograms as a freak, twisting and distending the corners

57 **Clown Torture**, 1987. The Art Institute of Chicago, Watson F. Blair Prize Fund; W. L. Mead Endowment; Twentieth-Century Purchase Fund; Through prior gift of Joseph Winterbotham; Gift of Lannan Foundation

of his mouth in apparent self-torture, but also in simulation of intensely emotional expressions. Speaking of freaks, he has sported feet caked in clay for the color photograph *Feet of Clay* (1967, fig. 58), and lathered black dye on his testicles for the slow-motion silent film *Black Balls* (1969, fig. 59). He has made two sculptures of animals fabricated from taxidermy molds stacked atop one another, which look like a cross between geometric minimalism, ancient pyramidal sculptures, and a circus act. In videos, he has appeared to walk on the ceiling or on the walls, recalling the gravity-defying feats of acrobats. In a twist on juggling, he has futilely attempted to establish precise sonic rhythms by bouncing two balls between the ceiling and floor of his empty studio, and later, in a slow-motion film, he bounced his own two balls (as in testicles) up and down. He has made a harrowing version of a carousel (*Carousel,* 1988, fig. 60) in which steel and aluminum sculptures cast from taxidermy molds of five wild animals rotate on a circular steel contraption and sometimes drag across the floor. Even his famous sound piece *Get Out of My Mind, Get Out of This Room* (1968), featuring an audiotape aggressively vocalizing the message of the title, recalls the loud and seductive call of the carneys.

Sideshows, freak shows, scintillating attractions, extra-bright signage, and unusual feats all feed into Nauman's oeuvre, and as an artist he is something of a showman and impresario, calling our attention to an unnerving marvel in the next room, and after that to another suspicious attraction right over there. Still, his art is an inverted carnival, one that turns dazzling spectacle toward solitude, self-scrutiny, and a deliberate, at times painful and scathing, investigation of who he is, and who we are. His carnivalesque art is not escapist, but provocative and confrontational, inspiring one to contemplate the rougher aspects of humanness—lust, death, hunger, cruelty, disorientation, confusion, and desolation—as well as stubborn beauty, playfulness, and hope.

58 **Feet of Clay**, 1967, reprinted in portfolio **Eleven Color Photographs**, 1966-67/1970. Published by Leo Castelli Gallery, New York

59 Still from **Black Balls**, 1969. Courtesy Electronic Arts Intermix (EAI), New York

60 **Carousel**, 1988. Stedelijk Museum, Amsterdam

Central to this carnivalesque art are Nauman's neon signs, whether they feature language or images, as well as his rooms and corridors emanating fluorescent light. The neon light was invented by a Frenchman, Georges Claude, and first revealed to the public in 1910. Claude originally intended it to be an inexpensive and long-lasting light source for homes and buildings, but very quickly it was adopted by advertising as an eye-catching technological marvel that could stop passersby in their tracks. In America, the first neon sign was sold by Claude's company to a Los Angeles Packard dealership in 1923, and shortly thereafter the floodgates opened. America quickly became neonized, as makes sense in a country that has had utopian inclinations since the Puritans established their "New Jerusalem" in an obscure coastal corner of what came to be known as Massachusetts. Neon lights have the look of a plugged-in paradise, of newness and adventure, and they signal that a better or, at the very least, more exciting and risk-taking life is possible and available, starting right here and now, even in this city in the desert, even in this sour corner tavern. At the same time, they've got an air of licentiousness and malevolence: a dangerous current courses through this plugged-in paradise. As lovely as they are, they're also frankly manipulative, and while you know you're being scammed, advertised to, and ingeniously compelled, this comes with a satisfying note of whimsy and pleasure.

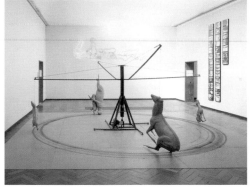

That's the cultural context Nauman infiltrates and transforms according to his own purposes and with his kind of inversions. If neon signs often posit communal vigor, like Broadway marquees or the Las Vegas strip, Nauman's are obdurately lonely and alienated, and sometimes suggest solitude, absence, and mortality. A 1966 work called *Neon Templates of the Left Half of My Body Taken at Ten-Inch Intervals* (fig. 38) consists of several glass arcs demarcating incremental spaces on the left part of his body. This glowing work is a system of rudimentary measurements—Nauman, who studied physics and mathematics in college before moving on to art, has long been interested in calibrations and measurements—but it goes much further than that. Replete with dangling electric cables, it looks vaguely skeletal and oddly supernatural: the "body electric" as Whitman once wrote, with intimations of dynamism and ecstasies, but also the body degraded and broken down into truncated vertebrae. Moreover, while this work is a total presence in the space, it also signifies absence: Nauman's own absence (after all, he was once right there, in the hollow of this sculpture, but now he's gone), but, even more, the permanent absence of his body, which comes with shuddering connotations. In fact, one hallmark of Nauman's neons is their evocation of mortality, whether overt or implicit. Reconfiguring the seductive aesthetic of neon signs to deal with the messy business of death is a startling enterprise.

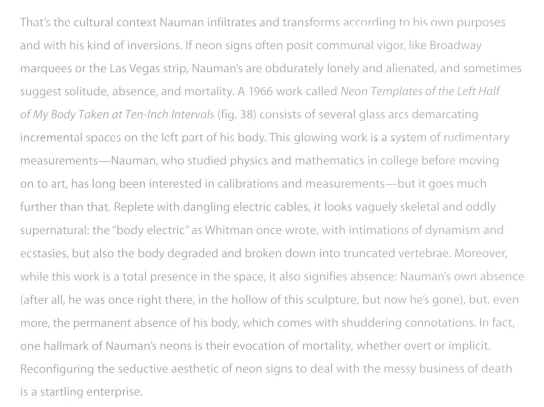

Nauman's other investigations of selfhood in neon signs are equally engaging. For *My Last Name Exaggerated Fourteen Times Vertically* (1967, fig. 7), he rendered his extended signature in pale purple neon. The elongated "Nauman" is a wonderful quasi-abstract sculpture in its own right, but it also looks like a seismographic reading during an earthquake or an alarming electrocardiogram. A great deal of nervousness is packed into the surname, which now seems near-illegible, as if the familiar name one affixes to letters, checks, drawings, or paintings had morphed uncontrollably, getting all out of whack. What also happens is something similar to how one sees oneself in a funhouse mirror, perhaps with an extremely long face, a narrow torso, and elastic legs that seem to stretch on forever. With *My Name As Though It Were Written on the Surface of the Moon* (1968, fig. 62), Nauman's attenuated first name sprawls across the wall in white neon tubing, the visual equivalent of a reverberating echo:

bbbbbbrrrrrruuuuuuccccccceeeeee

Names, and especially first names, are, of course, the most primary demarcations of selfhood: Bruce is Bruce and I am Gregory. The problem, however, is that most names are not unique. Also, we could just as likely have different names, if our parents had so chosen, and we probably almost did. In physicalizing his first name, extending it out of proportion, and doing it all up in neon, Nauman sets up conditions in which one can examine the name as an alien object, and what one finds is that it is a word, nothing more, a system of shapes, and that it comes nowhere close to articulating what Whitman once memorably called the "Me myself." In one of many moments of synesthesia in Nauman's work, one feels this silent name emitting a great deal of sound, like an anxious or exasperated mother hollering her child's name at the top of her lungs: "Bbbbbbrrrrrruuuuuuccccccceeeeee!" Suddenly fear, anxiety, anger, hopefulness, adventure, and fragility begin to course through and around the word. Childhood fills these glass tubes, not merely neon gas. Self-awareness and nerve-racking alienation abruptly share close quarters and, as often happens with Nauman's work, the very public medium of a neon sign becomes both deeply introspective and downright hilarious.

On the face of it, Nauman's tour-de-force *One Hundred Live and Die* (1984, fig. 5) is one of his most resolutely impersonal works. Four vertical columns of tubing present one hundred rudimentary life actions as mirrored opposites: Live and Die—Live and Live, Play and Die—Play and Live, Scream and Die—Scream and Live. Rendered in multiple colors, and carefully calibrated to form ever-shifting visual patterns, this visual extravaganza is also searing in the way it gets to the heart of our permanent human troubles: we desire so much and rage so much, and our basic actions (whether fucking, crying, laughing, or eating) seem so elemental and essential, yet we are brief, and will vanish along with all the daily things we do. Of course, Nauman's work subverts advertisement codes and detonates just about all ideological logic based on inducing one to think and act in a particular way. Instead, one is confronted with unsolvable contradictions having to do with human energy and futility, hopefulness and despair, and, ultimately,

with living and dying. Still, there is something remarkably poignant and, one suspects, intensely personal about this work. It is an ultra-public rendition of the profound anxiety that can visit one without warning, when mortality looms large and when both one's own best efforts and usual activities seem altogether pointless. Still, for every "die" in the work there is a corresponding "live," signaling a stubborn appetite for life and a stoic endurance worthy of Samuel Beckett; Beckett has, in fact, been an abiding influence on Nauman.

5

If neon signs typically deliver a convincing message ("buy this Coke," "drink this beer," "drive this Packard," "gamble here"), Nauman's offer conundrums and ambiguities, augmented by his frequent use of anagrams, palindromes, puns, the juxtaposition of opposites, and other forms of wordplay, and they usually leave one guessing as to what, if any, the meaning actually is. *Run from Fear, Fun from Rear* (1972, fig. 61) is a perfect example. The first yellow phrase is on top, and the second pink phrase is below. By merely reversing two letters, R and F, to achieve chiasmus, Nauman releases a host of possibilities. We run from fear but also are enticed by and perhaps attracted to the scary thing behind us. "Run from Fear" is an imperative construction, and suggests an authoritative voice commanding one to do something urgent. "Fun from Rear," on the other hand, is a far more interior and subjective voice, and it has an air of creepy derangement. One way (among others) of interpreting this work is as a possible rape scene,

61 **Run from Fear, Fun from Rear**, 1972. Museum of Contemporary Art, Chicago, Gerald S. Elliott Collection

62 **My Name As Though It Were Written on the Surface of the Moon**, 1968. Stedelijk Museum, Amsterdam (following spread)

bbbbbbrrrrrrrruuu

featuring a victim in flight from a leering pursuer. If so, this is one of many times in Nauman's signs when interpersonal encounters lurch into violence, misunderstanding, and potential mayhem. Of course, the whole sequence could also signal the pleasure and pain of a sadomasochistic encounter; a fear of and attraction to homosexual pleasures; and probably many other things as well. Even at their most succinct, Nauman's signs are open-ended.

Elsewhere, the artist's clipped wordplay has a deeply moral and politically engaged streak, although he resists anything smacking of commentary or dogmatism. With *Eat/Death* (1972, fig. 18), "EAT" in yellow neon is superimposed on a blue neon "DEATH," accentuating the embedding of the first word in the second. This is an interesting word game, but one with consequences. We eat to keep from dying, but to eat we also kill, which can involve routine cruelty. We are thereby personally and bodily implicated in questions of power, violence, and control. In the meantime, this sign is a topsy-turvy version of the many "Eat Here" neons that one finds in roadside diners and small town cafes. *Raw War* (1970, fig. 63) features the word "WAR" in neon tubing, and below it several cables leading to a timing device on the floor. The whole work looks a bit like an explosive device. In this palindrome piece, lighting occurs in a reverse, right-to-left sequence: first the R flashes on and off, then the A is illuminated and remains on, then both W and R flash on to form the word "WAR," at which point the work goes dark, and the sequence begins again.

In 1970 President Richard Nixon authorized a secret United States and South Vietnamese incursion into Cambodia, thereby significantly escalating the Vietnam War, and leading to huge protests in the U.S. Also that year, Ohio National Guardsmen shot and killed four student protesters at Kent State University, and military trials began for Captain Ernest L. Medina and Lieutenant William Calley on charges of murder for their actions during the 1968 My Lai massacre. Pol Pot emerged as the leader of the Khmer Rouge in Cambodia in 1970; he and his cohorts would go on to kill millions. Lumbering American B-52s dropped tons of bombs on Vietnam that year, while Secretary of State Henry Kissinger was engaged in secretive "peace talks" with North Vietnamese officials. This was, in short, the rawest of the Vietnam-era years in America, and Nauman's sign turns a de facto advertisement into an enigmatic yet unstinting meditation on violence and upheaval.

With *Violins Violence Silence* (1981–82, fig. 20), the similarly sounding words of the title appear in both forwards and backwards lettering forming a triangular shape; when superimposed on one another, the words and their meanings blur together. Here, Nauman's seemingly fun-loving wordplay has drastic repercussions. Violence often results in violins, as in funeral music, as well as in silence: the silence of victims and the silence of those who chose not to bear witness or to oppose, whether in Germany during the Holocaust, in America during the Vietnam War, in several Latin American and South American countries during the 1970s, or, for that matter, right now. This linguistic work thus hauntingly evokes mass violence, along with corresponding

63 **Raw War**, 1970. The Baltimore Museum of Art, gift of Leo Castelli, New York

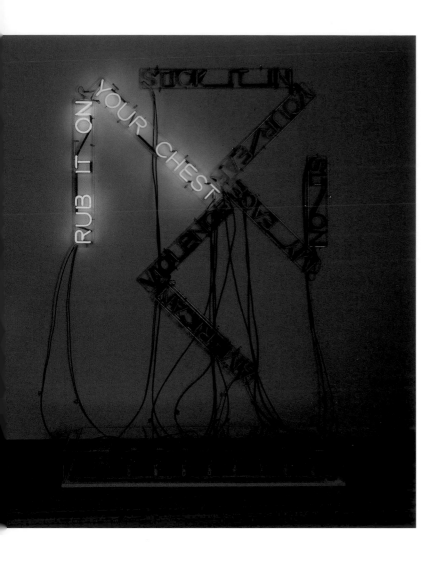

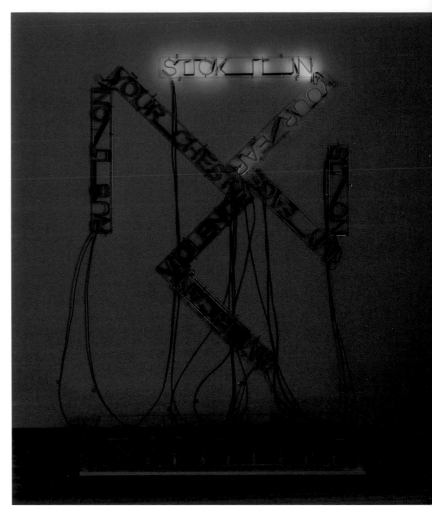

issues of memory (or the lack thereof) and responsibility (or the lack thereof). *American Violence* (1981–82, fig. 64) constitutes a very different take on what President Ronald Reagan later termed this "quiet, pleasant, greening land called America." Nauman's work features two familiar phrases of bodily intrusion: "Stick it in your ear" and "Sit on my face." The more unusual phrase "Rub it on your chest" (once exclaimed by a man in Pasadena who had stopped Nauman for a light only to be told that "I don't smoke") also appears, as well as the words "American Violence." Constructed in two superimposed layers of neon, these phrases flash individually around the work in sequence, and then all are illuminated at once.

All four of these phrases form an ominous, vaguely swastika-like shape, and because they are physically distorted, one has to slow down merely to comprehend exactly what is written. Each phrase begins to seem more aggressive and intrusive than usual, perhaps because the objects are accentuated: Your Ear, My Face, Your Chest. Vernacular phrases that normally would be forgotten once uttered now stick around, and the more one examines them the more strange and frightening they seem, for they hint at compulsion, obsession, and a desire to manipulate the minds and bodies of others, especially sexually. Rather than looking for "American Violence"

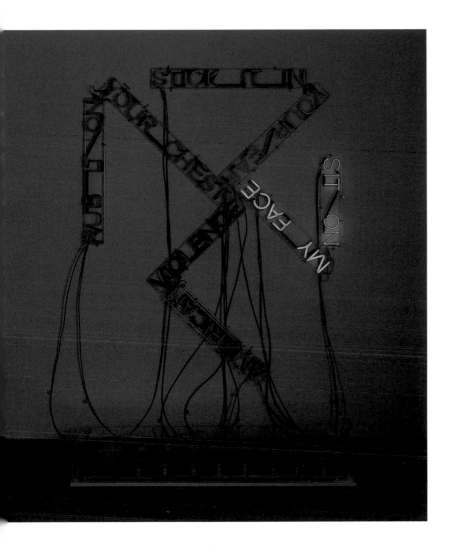
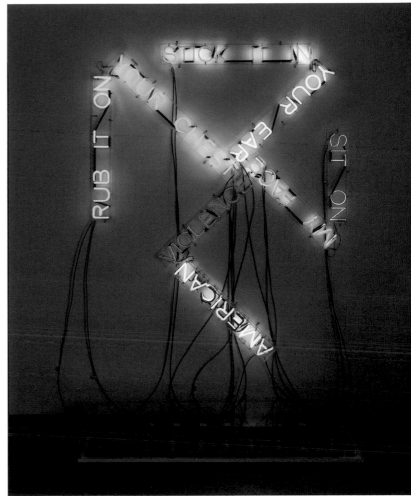

in wars, geopolitical machinations, or corporate malfeasance, Nauman finds it in figures of speech that are used all the time, and in the new neon context the expressions seem sinister and combustible, suggesting outbreaks of violence, whether in a war or a bar. At the same time, there is something ridiculous and, once again, hilarious about seeing such bad speech or dirty talk in the snappy medium of neon.

6

Increasingly during the 1980s Bruce Nauman turned to images in his neons, especially stick figures, some of them clowns with bulbous heads and outsized hands, and others rudimentary silhouettes of women and men. While these works are rooted in assiduous draftsmanship, the images resemble a six-year-old's drawings or an adult's doodles, giving them an air of whimsy and playtime. Whimsy and playtime easily shade into danger and malice (*Malice* is the title of a 1980 neon [fig. 65] in which the word, reading backwards, is superimposed on the same word reading forwards). This shift in tone occurs notably in *Hanged Man* (1985, fig. 27), based on the familiar game in which children try to guess the letters of a secret word. Here, there are no letters and no guessing, but instead a colorful stick figure that assembles itself limb-by-limb

64 **American Violence**, 1981–82. Friedrich Christian Flick Collection

beneath a gallows. When the figure is complete, another spasmodic, white neon figure appears with an erect penis, and suddenly this "game" suggests execution for real—torture and a strangled body's involuntary reactions.

In *Mean Clown Welcome* (1985, fig. 56), two clowns greet each other with a frantic and repetitive handshake, as they alternately stand and crouch, while sporting penises that shuttle constantly between flaccid and erect states. Sexual arousal, camaraderie, kinship, subliminal aggression, and a robotic repetitiveness all meld together in this herky-jerky piece, which hints at snarled psyches and twisted impulses. Other works, for instance *Double Slap in the Face* (1985, fig. 66), in which two men slap the heck out of each other over and over, and *Punch and Judy: Kick in the Groin, Slap in the Face* (1985), in which a man slaps a woman and is in turn kicked in the groin, are humorous yet deeply disturbing renditions of interpersonal aggression. Sex figures prominently in many of these works, always with abundant complications, as private impulses and desires are transformed into a brash, multicolored, obviously public aesthetic. In *Sex and Death/Double "69"* (1985), two pairs of figures, one upright and the other upside down, engage in mutual oral sex, but also resemble corpses laid out before burial. A striking thing here is how the gender of the figures keeps changing within the superimposed layers of neon. The clinically titled *Human Sexual Experience* (1985) is an animated neon version of a common gesture for sexual intercourse; here, the index finger of one disembodied blue hand endlessly pokes into a circle formed by the index finger and thumb of a second disembodied yellow hand. Nauman has referred to this work as the "beautiful stuff of curves and colors and sign language—kids' sign language, innocent, funny, simple." While it is indeed funny, it is anything but innocent and simple. Two hands detached from bodies seem alienated and bereft, and the sexual intercourse they simulate seems lackluster and mechanical. What all of these signs accomplish is to situate the viewer in an eternal "now" in which violence is endlessly repeated, trouble is the norm, psychological complications abound and are never resolved, and all attempts at communion, whether sexual or otherwise, seem fraught with peril. At the same time, these signs are alluring—Nauman consistently excels at such contradictions and ambiguities.

7

Here is an excerpt from poem 1129 by Emily Dickinson which speaks directly to Bruce Nauman's ambivalence, withholding, double-entendres, feints, and surprises:

Tell all the truth, but tell it slant
Success in circuit lies.

In our day, and working across his several mediums, Bruce Nauman has been an extraordinary purveyor of such "slant truth," which alludes to—but hardly exposes or renders manageable—complex psychologies and problematic social encounters, and leaves the viewer at once

65 **Malice**, 1980. Helen N. Lewis and Marvin B. Meyer, Beverly Hills, California

66 **Double Slap in the Face**, 1985. Froehlich Collection, Stuttgart

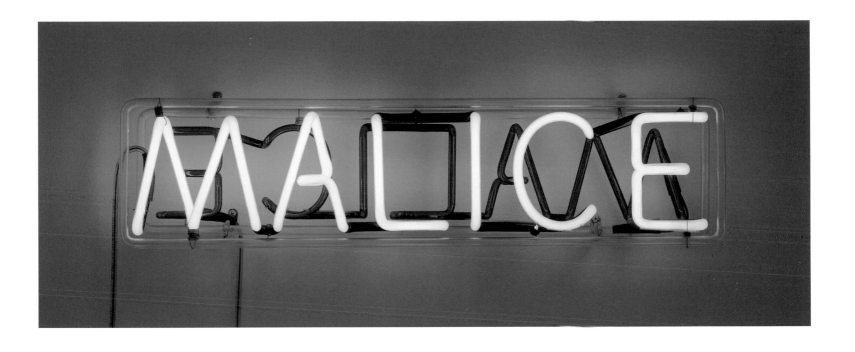

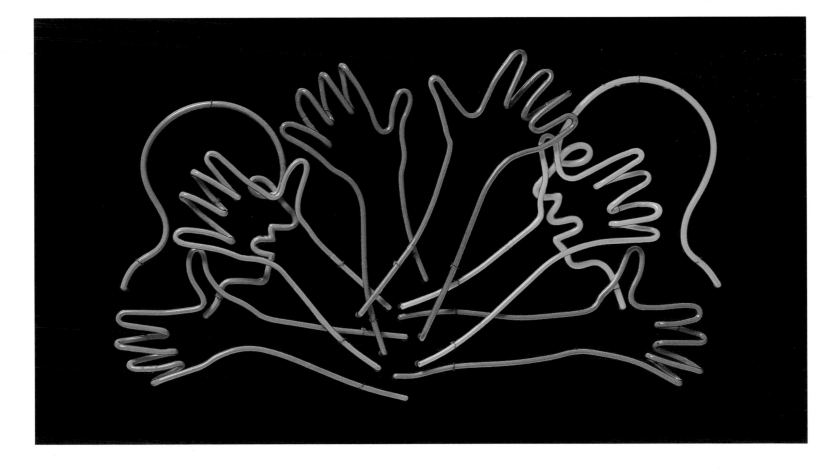

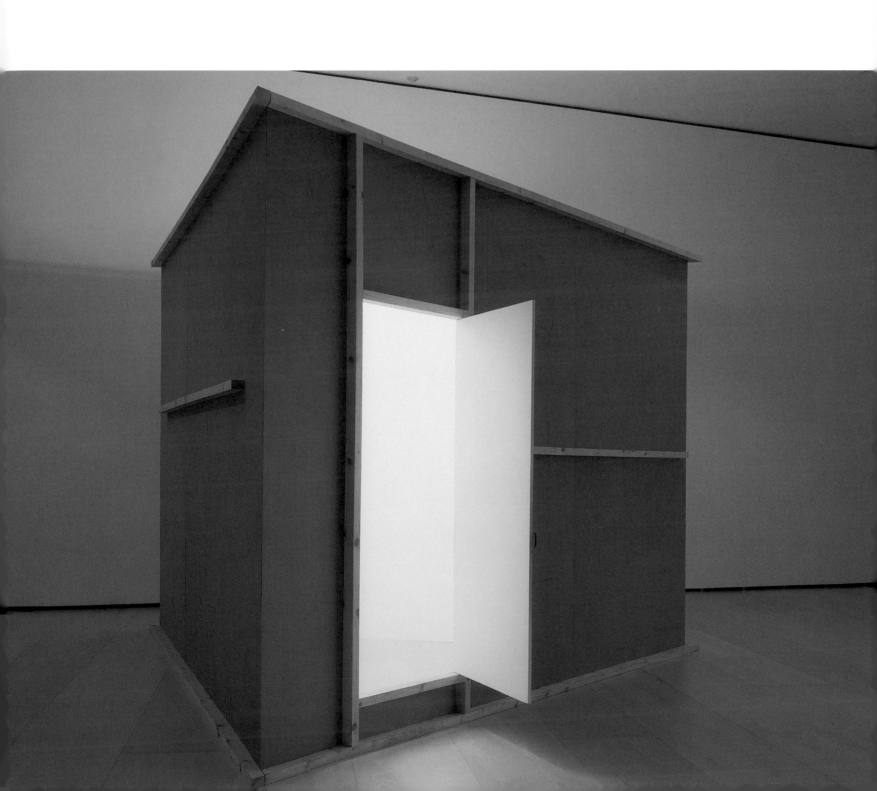

hyper-alert and shaken. Much of this art (and certainly most of Nauman's neon work) inhabits a carnivalesque world that is part visual wonderment and part uncomfortable confrontation, and while it places one in conditions of perceiving (and thinking) freshly, it also leaves one wary. In addition to numerous neons, a trio of architectural works illuminated by fluorescent light—*Yellow Room (Triangular)* (1973, fig. 67); *Floating Room: Lit from Inside* (1972, fig. 68); and *Green Light Corridor* (1970, fig. 4)—are stellar examples of this effect. In each case, simple architectural structures emanating light hold out the possibility of being zones of psychological and spiritual invigoration and transformation; they are like physical manifestations of the "mystic truths" in Nauman's early neon sign. At the same time, various means are used to undercut this invigoration. The floating room, while ethereal, seems dangerous and unnervingly lonely. The yellow room is magical, but intrudes aggressively into the space at an odd angle and could as easily be a place for confinement and torture as meditation. The glowing corridor, lit from above, is inviting and mysterious, but also narrow and restrictive. It suggests a difficult world tightening around one, while it literally alters one's vision, making one's own skin look gray, and leaving a magenta after-image when one exits.

Bruce Nauman's neons, as well as his illuminated architectural structures, constitute an exceptionally nuanced and multilayered body of work. Sharing the entertainment value and eye-popping power of a carnival aesthetic, these works deal in challenging themes, from mortality and violence to the slipperiness of language, the mystery and foibles of sex, fractious encounters between people, and the vexations of the self. Bruce Nauman's works involve "miles of stare": at the surrounding society and into the individual psyche, including their most searching and most tawdry aspects.

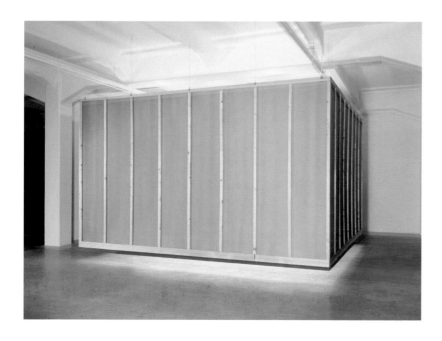

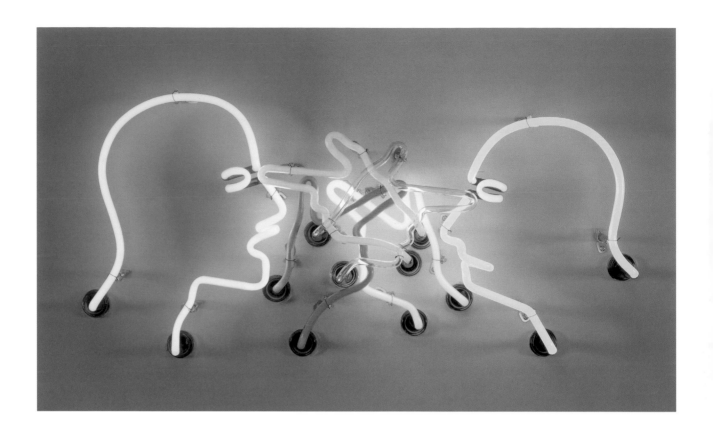

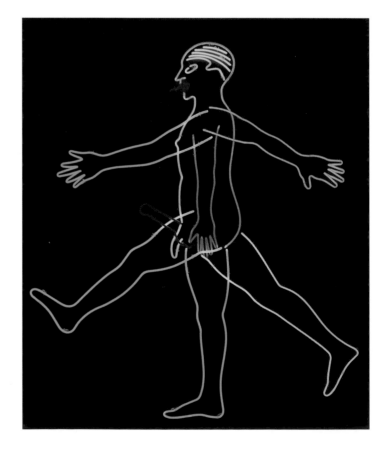

69 **Double Poke in the Eye II**, 1985. Courtesy
 Sperone Westwater, New York

70 **Marching Man**, 1985. Hamburger Kunsthalle,
 Hamburg, Germany

71 **Sex and Death by Murder and Suicide**, 1985.
 Emanuel Hoffmann Foundation, permanent loan
 to the Öffentliche Kunstsammlung Basel

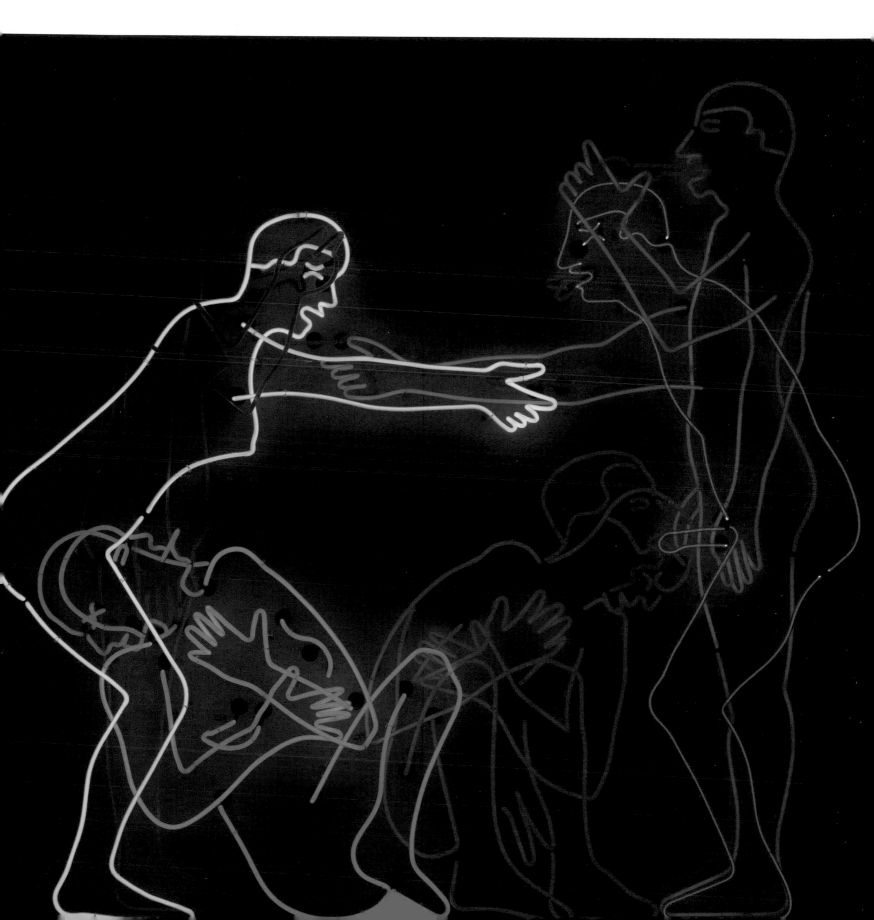

NOTES

Foreword
DAVID GORDON

[1] Brooks Adams, "The Nauman Phenomenon," *Art & Auction* (Dec. 1990), 123.

[2] Peter Plagens, "Roughly Ordered Thoughts on the Occasion of the Bruce Nauman Retrospective in Los Angeles," *Artforum* 11, no. 7 (Mar. 1973), 59.

[3] Ibid.

[4] Robert Pincus-Witten, "Bruce Nauman: Leo Castelli Gallery," *Artforum* 6, no. 8 (Apr. 1968), 63; and Pincus-Witten, "Another Kind of Reasoning," *Artforum* 10, no. 6 (Feb. 1972), 35.

[5] Robert C. Morgan, ed., *Bruce Nauman* (Baltimore: Johns Hopkins University Press, 2002), 150.

[6] Ibid., 100, 37, 211.

ELUSIVE SIGNS
Bruce Nauman Works with Light

JOSEPH D. KETNER II

[1] Of the 396 pieces that Nauman created from the beginning of his career in 1965 until 1988 (the date of his last light work), one-quarter (101) involve the use of neon, fluorescent, incandescent, and sodium lights. He also created an additional number of works with light as a student that were destroyed (3). See Neal Benezra et al., *Bruce Nauman: Exhibition Catalogue and Catalogue Raisonné*, exh. cat. (Minneapolis: Walker Art Center, 1994).

[2] Brenda Richardson, *Bruce Nauman Neons*, exh. cat. (Baltimore: Baltimore Museum of Art, 1983).

[3] Walt Whitman, *Song of Myself* (New York: Powgen Press, 1936); the poem first appeared in 1855 in Whitman's self-published first edition of *Leaves of Grass*.

[4] Bruce Nauman, interview by Jane Livingston, 1972, in Livingston and Marcia Tucker, *Bruce Nauman: Work from 1965 to 1972*, exh. cat. (Los Angeles: Los Angeles County Museum of Art, 1972), 11.

[5] Bruce Nauman, interview by Joe Raffaele, in Raffaele and Elizabeth Baker, "The Way-Out West: Interviews with 4 San Francisco Artists," *ARTnews* 66, no. 4 (Summer 1967), repr. in Janet Kraynak, ed., *Please Pay Attention Please: Bruce Nauman's Words: Writings and Interviews* (Cambridge, Mass., and London: MIT Press, 2003), 109.

[6] Amei Wallach, "Artist of the Showdown," *Newsday*, 8 Jan. 1989, repr. in Robert C. Morgan, ed., *Bruce Nauman: Art & Performance Series* (Baltimore: Johns Hopkins University Press, 2002), 39.

[7] Bruce Nauman, interview by Michele De Angelus, 27 and 30 May 1980, for the California Oral History Project (Washington, D.C.: Archives of American Art, Smithsonian Institution, 1980), published in Kraynak, *Please Pay Attention Please*, 278.

[8] Bruce Nauman, quoted in Coosje van Bruggen, *Bruce Nauman* (New York: Rizzoli, 1988), 7; Richardson, *Nauman Neons*, 20; Nauman, interview by De Angelus, in *Please Pay Attention Please*, 252.

[9] Bruce Nauman, in interview by Jan Butterfield, "Bruce Nauman—The Center of Yourself," *Arts Magazine* 49 (Feb. 1975), repr. in Kraynak, *Please Pay Attention Please*, 180.

[10] Janet Kraynak treats this neon in depth in her essay for the current catalogue.

[11] Nauman, interview by De Angelus, in Kraynak, *Please Pay Attention Please*, 230.

[12] Janet Kraynak discusses this idea in her essay for the current catalogue. Robert Storr also elaborates on this concept as a central premise in his essay "Beyond Words," in Benezra, *Nauman*, 57.

[13] Nauman, in Livingston and Tucker, *Bruce Nauman*, 21.

[14] Phenomenology was a central topic of critical discussion about Nauman's work at this time. See Marcia Tucker, "PheNAUMANology," *Artforum* 9 (Dec. 1970), 38-44; and Robert Pincus-Witten, "Bruce Nauman: Another Kind of Reasoning," *Artforum* 10 (Feb. 1972), 30-37.

[15] In works such as *Learned Helplessness in Rats (Rock and Roll Drummer)* (1986, Collection of Elaine and Werner Dannheisser), *Rats and Bats (Learned Helplessness in Rats II)* (1988, Museum of Contemporary Art, Chicago, Collection of Gerald S. Elliot), and *Fat Chance John Cage* (2001, Dia Art Foundation, New York), Nauman literally recreates scientific behavioral studies on rats to stimulate reflection on our own conditioned behavior.

[16] Michael Auping, "A Thousand Words: Bruce Nauman Talks About Mapping the Studio," *Artforum* 40, no. 7 (Mar. 2002), 121.

[17] Quoted by Amei Wallach in Morgan, *Bruce Nauman*, 41.

[18] *Corridor Installation (Nick Wilder Installation)* (1970), collection of the artist; *Live-Taped Video Corridor* (1970), Solomon R. Guggenheim Museum, New York, Panza Collection; *Video Surveillance Piece (Public Room, Private Room)* (1969-70), Solomon R. Guggenheim Museum, New York, Panza Collection; and others.

[19] Nauman, interview by De Angelus, in Kraynak, *Please Pay Attention Please*, 259, 261.

[20] Janet Kraynak, "Dependent Participation: Bruce Nauman's Environments," *Gray Room* 10 (Winter 2003), 40.

[21] Nauman, interview by Livingston, in Livingston and Tucker, *Bruce Nauman*, 24.

[22] Quoted in an interview by Christopher Cordes, *Bruce Nauman: Prints 1970–1989, A Catalogue Raisonné* (New York: Castelli Graphics, Lorence-Monk Gallery, Donald Young Gallery, 1989), repr. in Kraynak, *Please Pay Attention Please*, 353.

[23] Bruce Nauman, interview by Joe Raffaele, 1967, in Kraynak, *Please Pay Attention Please*, 109.

[24] Quoted in Richardson, *Nauman Neons*, 20.

[25] Ibid., 23–24, 27.

[26] Bruce Nauman, interview by Christopher Cordes, in Kraynak, *Please Pay Attention Please*, 354.

[27] *Diamond Africa with Chair Tuned DEAD* (1981), The Art Institute of Chicago, Mr. and Mrs. Frank G. Logan Prize; and *South American Triangle* (1981), Hirshhorn Museum and Sculpture Garden, Smithsonian Institution, Washington, D.C.

[28] Bruce Nauman in Bob Smith, "Bruce Nauman Interview," *Journal* (Los Angeles Institute of Contemporary Art) 4 (Spring 1982), repr. in Kraynak, *Please Pay Attention Please*, 299.

[29] Nauman, interview by De Angelus, in Kraynak, *Please Pay Attention Please*, 285.

[30] Bruce Nauman, in Joan Simon, "Breaking the Silence: An Interview with Bruce Nauman," *Art in America* 76 (Sept. 1988), 143.

[31] Kraynak introduced the idea that the imperative verb was a key element in all of Nauman's text works. See Kraynak, *Please Pay Attention Please*, 22–23.

[32] Arthur C. Danto, "Bruce Nauman," *Nation,* 8 May 1995, repr. in Morgan, *Bruce Nauman,* 150.

[33] Brooks Adams, "The Nauman Phenomenon," *Art & Auction* (Dec. 1990), 124.

[34] Nauman, in Simon, "Breaking the Silence," 203. Gregory Volk develops the idea of clowns in Nauman's art in his essay in the current catalogue.

[35] Nauman, interview by Cordes, in Kraynak, *Please Pay Attention Please,* 374.

[36] Ibid.

[37] Van Bruggen, *Bruce Nauman,* 24.

[38] Bruce Nauman, interview by Jan Butterfield, 1975, in Kraynak, *Please Pay Attention Please,* 182.

[39] *Human Sexual Experience* (1985), collection of Ed Ruscha, Los Angeles; *Masturbating Man* (1985), collection of Selma and Jos Vandermolen, Ghent, Belgium; *Masturbating Woman* (1985), private collection, Belgium; and *Seven Figures* (1985), Stedelijk Museum, Amsterdam.

[40] Nauman, in Simon, "Breaking the Silence," 147.

[41] Bruce Nauman, interview by Joan Simon, in Mary Livingstone Beebe et al., *Landmarks: Sculpture Commissions for the Stuart Collection of the University of California, San Diego* (New York: Rizzoli, 2001), repr. in Kraynak, *Please Pay Attention Please,* 392–93.

[42] Bruce Nauman, interview by Brenda Richardson, in Richardson, *Nauman Neons,* 29.

[43] Nauman, interview by De Angelus, in Kraynak, *Please Pay Attention Please,* 275.

[44] Kathryn Hixson, "Nauman: Good and Bad," *New Art Examiner* (Dec. 1994), repr. in Morgan, *Bruce Nauman,* 109.

[45] Nauman, interview by De Angelus, in Kraynak, *Please Pay Attention Please,* 249.

[46] Nauman in Simon, "Breaking the Silence," 148.

[47] Pamela M. Lee, "Pater Nauman," *October,* no. 74 (Fall 1995), 132.

SIGNS AND SYSTEMS
On Nauman's Neon Templates and Other Works

JANET KRAYNAK

I want to thank Stefano Basilico and Susan Laxton for their help in the preparation of this essay. Also, I want to acknowledge Yve-Alain Bois, Benjamin Buchloh, and Michael Leja, under whose guidance my work on Nauman developed and from which it continues to be inspired.

[1] Early writings that discuss Nauman's as well as other artists' work of the period in this context include Willoughby Sharp, "Bodyworks: a pre-critical, non-definitive survey of very recent works using the human body or parts thereof," *Avalanche,* no. 1 (Fall 1970), 14–17, and Cindy Nemser, "Subject-Object Body Art," *Arts Magazine* 46, no. 1 (Sept.–Oct. 1971), 38–42.

[2] Kristine Stiles, "Uncorrupted Joy: International Art Actions," in Paul Schimmel, ed., *Out of Actions: Between Performance and the Object, 1949–79,* exh. cat. (Los Angeles: Museum of Contemporary Art, 1998), 228.

[3] For example, Ira Licht, in a catalogue essay for the 1975 exhibition *Bodyworks* (which included Nauman's photograph *Self-Portrait as Fountain*), wrote: "Bodyworks is primarily personal and private. Its content is autobiographical and the body is used as the very body of a particular person rather than as an abstract entity or role.... Those artists—Lüthi, Nauman and Samaras, for example—who are in the tradition of the cult of the self, pose privately just for the photographic record.... It is the artist's physical being which bears the content and is both subject and means of aesthetic expression." Ira Licht, "Bodyworks," in *Bodyworks*, exh. cat. (Chicago: Museum of Contemporary Art, 1975), n.p.

[4] Here, I mean "signs" in a dual sense: the increasing appearance of actual "signs"—such as advertising or corporate logos—in public space, resulting in its privatization; and "signs" in the semiotic sense. In terms of the latter, the proliferation of signs led to an eradication of the "real," instigating a cultural condition that the philosopher Jean Baudrillard called "simulacral." "In this passage to a space whose curvature is no longer that of the real, nor of truth, the age of simulation thus begins with a liquidation of all referentials—worse: by their artificial resurrection in systems of signs.... It is no longer a question of imitation, nor of reduplication, nor even of parody. It is rather a question of substituting signs of the real for the real itself." Jean Baudrillard, "Simulacra and Simulations," in Mark Poster, ed., *Jean Baudrillard: Selected Writings* (Stanford: Stanford University Press, 1988), 167.

[5] Cited by Jane Livingston in Livingston and Marcia Tucker, *Bruce Nauman: Work from 1965 to 1972*, exh. cat. (Los Angeles and New York: Los Angeles County Museum of Art and Whitney Museum of American Art, 1972), 11.

[6] Bruce Nauman, in Willoughby Sharp, "Nauman Interview," *Arts Magazine* 44, no. 5 (Mar. 1970), repr. in Janet Kraynak, ed., *Please Pay Attention Please: Bruce Nauman's Words: Writings and Interviews* (Cambridge, Mass.: MIT Press, 2003), 127.

[7] Joe Raffaele and Elizabeth Baker, "The Way-Out West: Interviews with 4 San Francisco Artists," *ARTnews* 66, no. 4 (Summer 1967), repr. in Kraynak, *Please Pay Attention Please*, 106.

[8] Bruce Nauman, in Michele De Angelus, "Interview with Bruce Nauman, May 27 and May 30, 1980," in Kraynak, *Please Pay Attention Please*, 250.

[9] Nauman uses this term in relation to the sculpture *Shelf Sinking into the Wall with Copper-Painted Plaster Casts of the Spaces Underneath*: "It was one of my first pieces with a complicated title . . . a sort of functional title." Nauman, in Kraynak, *Please Pay Attention Please*, 127.

[10] For example, Johns's *Target with Plaster Casts* (1955), a painted target abutted by boxes containing cast body fragments, or his *Device Circle* (1959). In the latter, a stick, used to trace a circle into the painted field, was affixed to the painting's surface. A few years later, Robert Morris produced a series of body cast or imprint pieces, among which is *Untitled (Stairs)* (1964), a sculpture of three stairs with cast-lead footprints in the surface. Both Johns's and Morris's pieces recall Duchamp's indexical works, such as *Tu M'* (1918) and *Female Fig Leaf* (1950), among others.

[11] Rosalind Krauss, "Notes on the Index: Part 1," in her *The Originality of the Avant-Garde and Other Modernist Myths* (Cambridge, Mass.: MIT Press, 1985), 209. Here, Krauss established the connection to Duchamp's legacy. In Part 2 of the essay, she extends the discussion, focusing on an exhibition of recent work at the then-new contemporary art museum, P.S.1, in Long Island City, New York (210–19).

[12] By "photographic," I intend not just literal photographs, but in keeping with Krauss's argument, concerning, on the one hand, indexicality: "Every photograph is the result of a physical imprint transferred by light reflections onto a sensitive surface. The photograph is thus a type of icon, or visual likeness which bears an indexical relationship to its object." Ibid., 203. On the other hand, "photographic" connotes a reproductive, repetitive logic, which directly challenges modernism's pretense of originality and authenticity: As Krauss maintains, these are largely mythical constructs. See ibid., 151–70.

[13] Ibid., 215.

[14] The relationship of Nauman's work to a dialogical, performative model of language is the subject of my essay, "Bruce Nauman's Words," in Kraynak, *Please Pay Attention Please*, 1–45.

[15] Such slippages—or multiplicities—of meaning inform Nauman's many works (sculptures, photographs, text pieces, neon signs) that utilize double-entendre's, puns, idiomatic expressions, anagrams, and letter/word reversals. Examples are *Bound to Fail* (1967), a photographic work that literalizes the idiomatic expression of its title, or the neon piece *Run from Fear, Fun from Rear* (1972), in which the transposition of two letters produces a sexual innuendo. In these works, the possibility of linguistic transparency or a singular meaning is undermined, emphasizing the "tricks" or games that language can play.

[16] Erwin Panofsky, "The History of the Theory of Human Proportions as a Reflection of the History of Styles," *Meaning in the Visual Arts* (Chicago: University of Chicago Press, 1955), 56

[17] Ibid., 74. The ideal length of the body in the Byzantine system was nine units; as Panofsky explains, this "canon of 9 face-lengths" persisted well into later centuries. The singular ideal standard was challenged during the Renaissance by German painter and engraver Albrecht Dürer, who composed twenty-six alternative systems—or "types"—one of which, Type B, figured the body to be equivalent to seven heads, the standard used by Nauman in the Template sculptures and drawings.

[18] Bruce Nauman, quoted by Dieter Koepplin in his "Reasoned Drawings," in *Bruce Nauman: Drawings/Zeichnungen, 1965–1986*, exh. cat. and cat. rais. (Basel: Museum für Gegenwartskunst, 1986), 35, n. 10.

[19] As Hal Foster contends, the beholding subject of minimalist sculpture is conceived as "pre-linguistic": "Minimalism considers perception in phenomenological terms, as somehow before or outside history, language, sexuality, and power." Hal Foster, "The Crux of Minimalism," *The Return of the Real: The Avant-Garde at the End of the Century* (Cambridge, Mass.: MIT Press, 1996), 43.

[20] Mel Bochner, "The Serial Attitude," *Artforum* 6 (Dec. 1967), 28–33.

[21] For example, while the institutional frame (whether church, museum, gallery, or private collection) always informed the meaning of an artwork, artists such as Daniel Buren or Hans Haacke, to name just two examples, started in the late '60s to bring to the fore as primary content this often-unacknowledged dimension, which, importantly, is entirely legible to the viewer. This form of conceptual art—known as institutional critique—thus sought to expose hidden, and often ideologically charged, meanings in supposedly neutral institutional frames.

[22] For an excellent discussion of this and related works by Bochner, see Scott Rothkopf, "'Photography Cannot Record Abstract Ideas' and Other Misunderstandings," *Mel Bochner's Photographs, 1966–1969*, exh. cat. (Cambridge, Mass.: Harvard University Art Museums, 2002), 1–49.

[23] See Adachiara Zevi, ed., *Dan Graham, Selected Writings and Interviews on Art Works, 1965–95* (Rome: I Libri di Zerynthia, 1996), 133–34. For an important discussion of Graham's work produced for magazines, see Benjamin Buchloh, "Moments in the History of Dan Graham" (1978), repr. in Buchloh, *Neo-Avantgarde and Culture Industry: Essays on European and American Art from 1955–1975* (Cambridge, Mass.: MIT Press, 2000), 179–201.

[24] The neons, thus, are not so different from Nauman's architectural installations. In the latter, the museum or collector purchases not a physical object, but a set of diagrams or plans, and essentially a copyright allowing for the reproduction of the work according to a set of specifications.

[25] Jean François Lyotard, *The Postmodern Condition: A Report on Knowledge*, trans. Geoff Bennington and Brian Massumi (Minneapolis: University of Minnesota Press, 1984), 4–5.

[26] Among the many writings warning of the ills of the pending technocracy are: Jacques Ellul, *The Technological Society*, trans. John Wilkinson (New York: Knopf, 1967); Alain Touraine, *The Post-Industrial Society: Tomorrow's Social History: Classes, Conflicts, and Culture in the Programmed Society*, trans. Leonard F. X. Mayhew (New York: Random House, 1971); and Herbert Marcuse, *One-Dimensional Man: Studies in the Ideology of Advanced Industrial Society* (Boston: Beacon Press, 1964).

LIST OF ILLUSTRATIONS

41 **Human Nature/Knows Doesn't Know**, 1983/1986. Neon tubing with clear glass suspension frames, 90 x 90 x 14 inches. Froehlich Collection, Stuttgart

42 **Human Nature**, 1983. Neon tubing with clear glass tubing suspension frames, 91 x 64 x 2 1/4 inches. Collection of Martin Z. Margulies, Miami

43 **Human/Need/Desire**, 1983. Neon tubing with clear glass tubing suspension frames, 51 1/4 x 70 1/2 inches. The Museum of Modern Art, New York, gift of Emily and Jerry Spiegel 228.1991.a-g. Photograph © The Museum of Modern Art/Licensed by SCALA/Art Resource, New York

44 **Untitled (Study after "Wax Impressions of the Knees of Five Famous Artists")**, 1966. Ink, 19 x 24 inches. Emanuel Hoffmann Foundation, permanent loan to the Öffentliche Kunstsammlung Basel, acc. H 1973.14. Photograph by Martin Bühler, Kunstmuseum Basel

45 **Collection of Various Flexible Materials Separated by Layers of Grease with Holes the Size of My Waist and Wrists**, 1966. Aluminum foil, plastic sheet, foam rubber, felt, grease, 1 1/2 x 90 x 18 inches. Helen Acheson Bequest (by exchange) and gift of Douglas S. Cramer, (301.1997), The Museum of Modern Art, New York. © The Museum of Modern Art/Licensed by SCALA/Art Resource, New York. Photograph courtesy Sperone Westwater, New York

46 **Six Inches of My Knee Extended to Six Feet**, 1967. Fiberglass, polyester resin, 68 1/2 x 5 3/4 x 3 7/8 inches. Whitney Museum of American Art, New York. Partial and Promised Gift of Mr. & Mrs. Robert A. M. Stern to Whitney Museum of American Art, New York, 91.115M. Photograph by Sheldan C. Collins, New Jersey

47 **Body Is about 7 Heads**, 1966. Brown ink, 18 3/4 x 23 7/8 inches. Courtesy Galerie Konrad Fischer, Düsseldorf. Photograph by Claudia Pasko

48 **Wax Templates of the Left Half of My Body Separated by Cans of Grease**, ca. 1967. Wax, seven metal cans, approx. 72 inches h. Destroyed by artist. Photograph courtesy Sperone Westwater, New York

49 **Having Fun/Good Life, Symptoms**, 1985. Neon tubing mounted on aluminum monolith, 69 x 131 1/4 x 16 inches. Carnegie Museum of Art, Pittsburgh, purchase: Gift of the Partners of Reed Smith Shaw and McClay and Carnegie International Acquisitions Fund, 85.32

50 **Silence Is Golden/Talk or Die**, 1983. Neon tubing with clear glass tubing suspension frames, 20 x 50 x 7 inches. Donna and Howard Stone, Chicago. Photograph courtesy Sperone Westwater, New York

51 **Read Reap**, 1986. Neon tubing on metal monolith, 78 x 78 inches. J. P. Morgan Chase Art Collection

52 **This Is Fun/This Is the Good Life**, 1985. Neon tubing with clear glass suspension frame, 36 x 43 x 5 inches. San Francisco Museum of Modern Art, purchased through a gift of Dr. and Mrs. Allan Roos

53 **Seven Wax Templates of the Left Half of My Body Spread over 12 Feet**, 1967. Watercolor and pencil, 17 1/2 x 23 1/2 inches. Emanuel Hoffmann Foundation, permanent loan to the Öffentliche Kunstsammlung, Basel. Photograph by Martin Bühler, Kunstmuseum Basel

54 **Wax Template of My Body Arranged to Make an Abstracted Sculpture**, 1967. Ink, 25 x 19 inches. Washington Art Consortium: Henry Art Gallery, University of Washington, Seattle; Museum of Art, Washington State University, Pullman; Northwest Museum of Arts and Culture, Spokane; Seattle Art Museum; Tacoma Art Museum; Western Gallery, Western Washington University, Bellingham; Whatcom Museum of History and Art, Bellingham. Photograph © Rod del Pozo 2005

55 **Seven Figures**, 1985. Neon tubing mounted on wooden monolith, 86 5/8 x 185 inches. Stedelijk Museum, Amsterdam

56 **Mean Clown Welcome**, 1985. Neon tubing mounted on metal monolith, 72 x 82 x 13 inches. Udo and Anette Brandhorst Collection, Cologne

57 **Clown Torture**, 1987. 4 color video monitors, 4 speakers, 4 laserdisc players, 2 video projectors, 4 laserdiscs (color, sound), dimensions variable. The Art Institute of Chicago, Watson F. Blair Prize Fund; W. L. Mead Endowment; Twentieth-Century Purchase Fund; Through prior gift of Joseph Winterbotham; Gift of Lannan Foundation, 1997.162 No, No, No, No (Walter). Photograph © The Art Institute of Chicago

58 **Feet of Clay**, 1967. Color photograph, 23 1/2 x 22 1/2 inches, reprinted in portfolio **Eleven Color Photographs**, 1966-67/1970. Ed. of 8, published by Leo Castelli Gallery, New York. Photograph courtesy Sperone Westwater, New York

59 Still from **Black Balls**, 1969. 16-mm black-and-white silent film, 8 min. Courtesy Electronic Arts Intermix (EAI), New York. Photograph courtesy Sperone Westwater, New York

60 **Carousel**, 1988. Steel, aluminum, 84 inches h. Stedelijk Museum, Amsterdam. Photograph: Stedelijk Museum, Amsterdam

61 **Run from Fear, Fun from Rear**, 1972. Neon tubing with clear glass tubing suspension frame, two parts, 8 x 24 x 2 1/2 inches each. Ed. 4/6. Museum of Contemporary Art, Chicago, Gerald S. Elliott Collection. Photograph by Joe Ziolkowksi; photograph © MCA, Chicago

62 **My Name As Though It Were Written on the Surface of the Moon**, 1968. Neon tubing with clear glass tubing suspension frame, 11 x 204 x 2 inches. Ed. 3/3. Stedelijk Museum, Amsterdam. Photograph courtesy Sperone Westwater, New York

63 **Raw War**, 1970. Neon tubing with clear glass tubing suspension frame, 6 1/2 x 17 1/2 x 2 1/2 inches. Ed. 1/6. The Baltimore Museum of Art, gift of Leo Castelli, New York, BMA 1982.148

64 **American Violence**, 1981–82. Neon tubing with clear glass tubing suspension frame, 78 x 62 x 3 1/4 inches. Friedrich Christian Flick Collection. Photograph by Roman Maerz, Berlin

65 **Malice**, 1980. Neon tubing with clear glass tubing suspension frame, 7 x 29 x 3 inches. Ed. 2/3. Helen N. Lewis and Marvin B. Meyer, Beverly Hills, California. Photograph by Douglas Parker

66 **Double Slap in the Face**, 1985. Neon tubing mounted on metal monolith, 31 1/2 x 49 1/2 x 5 inches. Ed. 2/5. Froehlich Collection, Stuttgart

67 **Yellow Room (Triangular)**, 1973. Wallboard, plywood, yellow fluorescent lights, 120 x 177 x 157 inches. Solomon R. Guggenheim Museum, New York, Panza Collection, 1991, 91.3835. Photograph by Erika Barahona Ede

68 **Floating Room: Lit from Inside**, 1972. Wallboard, wood, fluorescent lights, 120 x 192 x 192 inches. Raussmüller Collection

69 **Double Poke in the Eye II**, 1985. Neon tubing mounted on aluminum monolith, 24 x 36 x 9 1/4 inches. Ed. of 40. Photograph courtesy Sperone Westwater, New York

70 **Marching Man**, 1985. Neon tubing mounted on aluminum monolith, 77 x 66 x 10 inches. Hamburger Kunsthalle, Hamburg, Germany

71 **Sex and Death by Murder and Suicide**, 1985. Neon tubing mounted on aluminum monolith, 75 3/16 x 75 3/16 x 12 inches. Emanuel Hoffmann Foundation, permanent loan to the Öffentliche Kunstsammlung Basel

EXHIBITION CHECKLIST

Neon Templates of the Left Half of My Body Taken at Ten-Inch Intervals, 1966. Neon tubing on clear glass tubing suspension frame, 70 x 9 x 6 inches. Estate of Philip Johnson, courtesy of the National Trust for Historic Preservation
(fig. 38)

The True Artist Helps the World by Revealing Mystic Truths (Window or Wall Sign), 1967. Neon tubing with clear glass tubing suspension frame, 59 x 55 x 2 inches. Ed. 2/3. Collection Kröller-Müller Museum, Otterlo, The Netherlands
(fig. 1)

My Name As Though It Were Written on the Surface of the Moon, 1968. Neon tubing with clear glass tubing suspension frame, 11 x 204 x 2 inches. Ed. 3/3. Stedelijk Museum, Amsterdam
(fig. 62)

None Sing Neon Sign, 1970. Neon tubing with clear glass tubing suspension frame, 13 x 24 1/2 x 1 1/2 inches. Ed. 6/6. Solomon R. Guggenheim Museum, New York, Panza Collection, 1991, 91.3825
(fig. 17)

Raw War (1970), neon tubing with clear glass tubing suspension frame, 6 1/2 x 17 1/2 x 2 1/2 inches. Ed. 1/6. The Baltimore Museum of Art: Gift of Leo Castelli, New York, BMA 1982.148
(fig. 63)

Corridor with Mirror and White Lights (Corridor with Reflected Image), 1971. Wallboard, fluorescent lights, mirror, 120 x 336 x 12 inches. Tate, purchased 1973. © Tate Gallery, London/Art Resource, New York
(fig. 13)

Helman Gallery Parallelogram, 1971. Wallboard, green fluorescent lights, 180 x 217 x 272 inches. Friedrich Christian Flick Collection
(fig. 15)

Run from Fear, Fun from Rear, 1972. Neon tubing with clear glass tubing suspension frame, two parts, 8 x 24 x 2 1/2 inches each. Ed. 4/6. Museum of Contemporary Art, Chicago, Gerald S. Elliott Collection
(fig. 61)

Violins Violence Silence, 1981–82. Neon tubing with clear glass tubing suspension frame, 62 3/16 x 65 3/8 x 6 inches. Camille O. Hoffmann Collection, Chicago
(fig. 20)

Life, Death, Love, Hate, Pleasure, Pain, 1983. Neon tubing with clear glass tubing suspension frame, 70 7/8 inch diameter. Museum of Contemporary Art, Chicago, Gerald S. Elliott Collection
(fig. 2)

Silence Is Golden/Talk or Die, 1983. Neon tubing with clear glass tubing suspension frames, 20 x 50 x 7 inches. Donna and Howard Stone, Chicago
(fig. 50)

One Hundred Live and Die, 1984. Neon tubing mounted on four metal moonlights, 118 x 132 1/4 x 21 inches. Benesse Art Site Naoshima, Naoshima, Japan
(fig. 5)

Five Marching Men, 1985. Neon tubing mounted on aluminum monolith, 79 1/4 x 129 1/8 x 11 1/2 inches. Friedrich Christian Flick Collection
(fig. 29)

Hanged Man, 1985. Neon tubing mounted on metal monolith, 86 5/8 x 55 x 10 3/4 inches. Ed. 1/3. Museum of Contemporary Art, Chicago, Gerald S. Elliott Collection
(fig. 27)

Mean Clown Welcome, 1985. Neon tubing mounted on metal monolith, 72 x 82 x 13 inches. Udo and Anette Brandhorst Collection, Cologne
(fig. 56)

White Anger, Red Danger, Yellow Peril, Black Death, 1985. Neon tubing with clear glass tubing suspension frame, 86 1/2 x 80 inches. Maricluise Hessel Collection on permanent loan to the Center for Curatorial Studies, Bard College, Annandale-on-Hudson, New York
(fig. 24)

ARTIST'S BIOGRAPHY

BORN

Fort Wayne, Indiana, 1941

EDUCATION

1964
B.S. University of Wisconsin, Madison

1966
M.F.A. University of California, Davis

TEACHING POSITIONS

1966–68
San Francisco Art Institute

1970
University of California, Irvine

SELECTED HONORS AND AWARDS

1968
NEA Grant, Artistic Fellowship Award, Washington, D. C.

1970
Aspen Institute for Humanistic Studies Grant, Colorado

1986
Skowhegan Award, Maine

1989
Honorary Doctor of Fine Arts, San Francisco Art Institute

1990
Max Beckmann Prize, Frankfurt am Main

1993
Alumni Citation for Excellence, University of California, Davis; The Wolf Foundation Prize in Arts (Sculpture), Herzlia, Israel

1994
The Wexner Prize, Ohio State University, Ohio

1995
Fellowship, American Academy of Arts and Sciences, Cambridge, Massachusetts; Aldrich Prize, The Aldrich Museum of Contemporary Art, Ridgefield, Connecticut

1997
Membership, Akademie der Künste, Berlin

1999
Leone d'oro (The Golden Lion), XLVIII Biennale di Venezia, Venice, Italy; Sagamore of the Wabash, Indianapolis, Indiana

2000
Membership, American Academy of Arts and Letters, New York; Honorary Doctorate of Arts, California Institute of the Arts, Valencia

2004
Praemium Imperiale Prize for Visual Arts, Japan; Best International Artist, Beaux-Arts Magazine Art Awards, Paris

ONE-PERSON EXHIBITIONS

1966
Master of Arts degree exhibition, University of California, Davis

Nicholas Wilder Gallery, Los Angeles

1968
Bruce Nauman, Leo Castelli Gallery, New York

Sacramento State College Art Gallery, California

6 Day Week: 6 Sound Problems, Galerie Konrad Fischer, Düsseldorf

1969
Nicholas Wilder Gallery, Los Angeles

Bruce Nauman: Holograms, Videotapes, and Other Works, Leo Castelli, New York

Galerie Ileana Sonnabend, Paris

Bruce Nauman: Photographs, School of Visual Arts, New York

1970
Bruce Nauman, Galerie Konrad Fischer, Düsseldorf

Galleria Sperone, Turin, Italy

Nicholas Wilder Gallery, Los Angeles

Untitled: Corridor Piece with Mirror, San Jose State College, California

Studies for Holograms, Galerie Ricke, Cologne

Galerie Bruno Bischofsberger, Zurich

Helman Gallery, St. Louis, Missouri

1971
Leo Castelli Gallery, New York

Galerie Ileana Sonnabend, Paris

Galerie Konrad Fischer, Düsseldorf

Left or Standing, Standing or Left Standing, Leo Castelli Gallery, New York

Helman Gallery, St. Louis, Missouri

Natural Light, Blue Light Room, Ace Gallery, Vancouver

Galerie Bruno Bischofsberger, Zurich

1972
Bruce Nauman: 16mm Filme 1967–1970, Ursula Wevers, Cologne

Helman Gallery, St. Louis, Missouri

Bruce Nauman: Work from 1965 to 1972, Los Angeles County Museum of Art; Whitney Museum of American Art, New York; Kunsthalle Bern, Switzerland; Städtische Kunsthalle, Düsseldorf; Stedelijk van Abbemuseum, Eindhoven, Netherlands; Palazzo Reale, Milan; Contemporary Arts Museum, Houston; San Francisco Museum of Art

1973

Bruce Nauman Floating Room, Fine Arts Gallery, University of California, Irvine

Bruce Nauman: Floating Room, Leo Castelli Gallery, New York

Flayed Earth/Flayed Self (Skin/Sink), Nicholas Wilder Gallery, Los Angeles

Image Projection and Displacement (No promises), Ace Gallery, Vancouver

1974

Yellow Body, Galerie Konrad Fischer, Düsseldorf

Yellow Triangular Room, Santa Ana College Art Gallery, California

Wall with Two Fans, Wide White Space, Antwerp

Bruce Nauman, P. M. J. Self Gallery, London

Galerie Art in Progress, Munich

Galerie Sonnabend, Paris

1975

Bruce Nauman: Cones/Cojones, Leo Castelli Gallery, New York

The Consummate Mask of Rock, Albright Knox Art Gallery, Buffalo, New York

Forced Perspective: Open Mind, Closed Mind, Equal Mind, Parallel Mind (Allegory and Symbolism), Galerie Konrad Fischer, Düsseldorf

1976

(Installation [Diamond Mind]), Atholl McBean Gallery, San Francisco Art Institute

Enforced Perspective: Allegory and Symbolism, Ace Gallery, Vancouver

White Breathing, UNLV Art Gallery, University of Nevada, Las Vegas

Drawings, Ace Gallery, Los Angeles

The Consummate Mask of Rock, Sperone Westwater Fischer; Leo Castelli Gallery; Ileana Sonnabend Gallery, New York; Nicholas Wilder Gallery, Los Angeles

1977

Bruna Soletti, Milan

1978

Bruce Nauman, Leo Castelli Gallery, New York

Large Studies in Combinations of Olive, Mustard and Pink Fiberglass and Polyester Resin in 4 Groups and One Study in Cast Iron All at 1:50 Scale of Combinations of Shafts, Trenches, and Tunnels, Galerie Konrad Fischer, Düsseldorf

Bruce Nauman, InK, Halle für Internationale neue Kunst, Zurich

1/12 Scale Study in Fiberglass and Plaster for Cast Iron of a Trench and Four Tunnels in Concrete at Full Scale, Art Gallery, California State University, San Diego

Wood, Plaster and Steel Works and Cor-Ten Steel Sculpture, Ace Gallery, Vancouver

1979

Galerie Schmela, Düsseldorf

Bruce Nauman, Marianne Deson Gallery, Chicago

Bruce Nauman: An Installation, Portland Center for the Visual Arts, Oregon

Large Scale Sculptures: Cor-Ten Steel, Ace Gallery, Los Angeles

Bruce Nauman: Prints, Hester van Royen Gallery, London

1980

Bruce Nauman, Leo Castelli Gallery, New York

Bruce Nauman: New Sculpture, Hill's Gallery of Contemporary Art, Santa Fe

North, East, South, South East, Galerie Konrad Fischer, Düsseldorf

Bruce Nauman, InK, Halle für Internationale neue Kunst, Zurich

Carol Taylor Art, Dallas

Forced Perspective or False Perspective: Drawings by Bruce Nauman, Nigel Greenwood, London

1981

Maud Boreel Print Art, The Hague

Bruce Nauman: 1/12 Scale Models for Underground Pieces, Albuquerque Museum, New Mexico

Stone Sculpture: Enforced Perspective. Allegory and Symbolism, Ace Gallery, Venice, California

Bruce Nauman, 1972–1981, Rijksmuseum Kröller Müller, Otterlo, Netherlands; Staatliche Kunsthalle, Baden-Baden, West Germany

Lessons, Texas Gallery, Houston

Bruce Nauman: New Iron Casting, Plaster, and Drawings, Young Hoffman Gallery, Chicago

Bruce Nauman: Photo Piece, Window Screen, Hologram, Neon Sculptures, Cast-Iron Sculpture, Drawings, 1967–1981, Galerie Konrad Fischer, Zurich

1982

Bruce Nauman: Violins, Violence, Silence, Leo Castelli Gallery and Sperone Westwater Fischer, New York

Bruce Nauman: Neons, The Baltimore Museum of Art, Maryland

1983

Carol Taylor Art, Dallas

Hoffnung/Neid, Galerie Konrad Fischer, Düsseldorf

Bruce Nauman: Dream Passage, Stadium Piece, Musical Chairs—Drei neue Arbeiten, Museum Haus Esters, Krefeld, West Germany

1984

Hallen für neue Kunst, Schaffhausen, Switzerland

Daniel Weinberg, Los Angeles

Bruce Nauman: New Sculptures and Drawings, Carol Taylor Art, Dallas

Room with My Soul Left Out, Leo Castelli Gallery, New York

Seven Virtues and Seven Vices: White Anger, Red Danger, Yellow Peril, Black Death, Sperone Westwater, New York

1985

New Work: Neons and Drawings, Donald Young Gallery, Chicago

New Neons, Galerie Konrad Fischer, Düsseldorf

Leo Castelli Gallery, New York

1986

Bruce Nauman, Texas Gallery, Houston

Bruce Nauman, Jean Bernier, Athens, Greece

Bruce Nauman: Oeuvres sur papier, Galerie Yvon Lambert, Paris

Bruce Nauman, Whitechapel Art Gallery, London; Kunsthalle Basel; ARC, Musée d'art moderne de la Ville de Paris, France

Bruce Nauman: Drawings/Zeichnungen, 1965–1986, Museum für Gegenwartskunst, Basel; Kunsthalle Tubingen, West Germany; Städtisches Kunstmuseum, Bonn, West Germany; Museum Boijmans Van Beuningen, Rotterdam; Kunstraum, Munich; Badischer Kunstverein, Karlsruhe, West Germany; Hamburger Kunsthalle Hamburg, West Germany; New Museum of Contemporary Art, New York; Contemporary Arts Museum, Houston; Museum of Contemporary Art, Los Angeles; University Art Museum, University of California, Berkeley

1987

Bruce Nauman: Neon and Video, Donald Young Gallery, Chicago

Daniel Weinberg Gallery, Los Angeles

1988

Bruce Nauman: Video, 1965–1986, Museum of Contemporary Art, Los Angeles

Bruce Nauman, Galerie Konrad Fischer, Düsseldorf

Galerie Micheline Szwajcer, Antwerp

Bruce Nauman, Sperone Westwater, New York

Bruce Nauman, Centre Georges Pompidou, Musée national d'art moderne, Paris

1989

Bruce Nauman: New Prints, Sperone Westwater, New York

Bruce Nauman: New Sculptures, Texas Gallery, Houston

Bruce Nauman: Druckgraphik, 1970–1988, Galerie Fred Jahn, Munich

Bruce Nauman: Heads and Bodies, Galerie Konrad Fischer, Düsseldorf

Bruce Nauman: Prints 1970–89, Castelli Graphics, New York; Lorence Monk Gallery, New York; Donald Young Gallery, Chicago; Earl McGrath Gallery, Los Angeles; Pence Gallery, Santa Monica, California

Bruce Nauman: A Survey, Anthony d'Offay Gallery, London

1990

Daniel Weinberg Gallery, Santa Monica, California

Bruce Nauman, Galerie B. Coppens and R. Van De Velde, Brussels

Bruce Nauman: Shadow Puppets and Instructed Mime, Sperone Westwater, New York

Bruce Nauman, Leo Castelli Gallery, New York

Bruce Nauman, 65 Thompson Street Gallery, New York

Bruce Nauman: Redierungen, Lithographien, Multiples, Galerie Jürgen Becker, Hamburg, West Germany

Bruce Nauman, Galerie Langer Fain, Paris

Bruce Nauman: Skulpturen und Installationen, 1985–1990, Museum für Gegenwartskunst, Siegen, West Germany; Städelsches Kunstinstitut und Städtische Galerie, Frankfurt am Main; Musée cantonal des Beaux-Arts, Lausanne, Switzerland

1991

Bruce Nauman, Daniel Weinberg Gallery, Santa Monica, California

Bruce Nauman: Prints, Gallery 360°, Tokyo

Bruce Nauman—OK OK OK, Portikus, Frankfurt am Main

Bruce Nauman, Galerie Metropol, Vienna

Bruce Nauman: Prints and Multiples, Thea Westreich, New York; Museum van Hedendaagse, Ghent, Belgium; Douglas Hyde Gallery, Trinity College, Dublin; Museum Boijmans Van Beuningen, Rotterdam; Heiligenkreuzerhof, Hochschule für Angewandte Kunst, Vienna; Institute of Contemporary Arts, London; City Museum, Stoke-on-Trent, England; Tel Aviv Museum of Art, Israel

Bruce Nauman, Fundació Espai Poblenou, Barcelona

1992

Bruce Nauman: Neons, Anthony d'Offay Gallery, London

Bruce Nauman, Salzburger Kunstverein, Salzburg, Austria

Bruce Nauman, Ydessa Hendeles Art Foundation, Toronto

1993

Bruce Nauman: Light Works, Washington University Gallery of Art, St. Louis, Missouri

Shoshana Wayne Gallery, Santa Monica, California

Bruce Nauman, Museo Nacional Centro de Arte Reina Sofía, Madrid; Walker Art Center, Minneapolis; Museum of Contemporary Art, Los Angeles; Hirshhorn Museum and Sculpture Garden, Smithsonian Institution, Washington, D.C.; The Museum of Modern Art, New York; Kunsthaus Zürich, Zurich

1994

Bruce Nauman: Falls, Pratfalls and Sleights of Hand, Leo Castelli Gallery, New York; Anthony d'Offay Gallery, London; Jean Bernier, Athens, Greece

Bruce Nauman: Sieben Tugenden und Sieben Laster, Galerie Konrad Fischer, Düsseldorf

1995

Bruce Nauman: Recent Prints and Monoprints, Baumgartner Galleries, Washington, D.C.

Bruce Nauman: Elliott's Stones, Museum of Contemporary Art, Chicago

1996

Bruce Nauman: Neue Arbeiten, Galerie Konrad Fischer, Düsseldorf

Bruce Nauman: Video and Sculpture, Sperone Westwater, New York

Bruce Nauman: Sculpture and Video, Leo Castelli Gallery, New York

1997

Bruce Nauman: Shadow Puppet Spinning Head, Galerie Hauser + Wirth, Zurich

Bruce Nauman, 1985–1996: Drawings, Prints, and Related Works, The Aldrich Museum of Contemporary Art, Ridgefield, Connecticut; Cleveland Center for Contemporary Art

Bruce Nauman, Casa Masaccio, San Giovanni Valdarno, Italy

Bruce Nauman: Image/Text, 1966–1996, Kunstmuseum Wolfsburg, Germany; Centre Georges Pompidou, Musée national d'art moderne—Centre de création industrielle, Paris; Hayward Gallery, London; Nykytaiteen museo Kiasma, Helsinki, Finland

1998

Bruce Nauman: Versuchsanordnungen, Werke 1965–1994, Hamburger Kunsthalle, Hamburg, West Germany

Bruce Nauman: Selected Works, 1970–96, Galleri Riis, Oslo

1999

Bruce Nauman, Donald Young Gallery, Chicago

Bruce Nauman: Flesh to White to Black to Flesh, The Contemporary Art Center, Cincinnati

Bruce Nauman: 1973–1988, Graphic Works, Galería Pepe Cobo, Seville

Setting a Good Corner (Allegory & Metaphor), Stedelijk Museum, Amsterdam

2001

Bruce Nauman, Selected Works, Zwirner & Wirth, New York

2002

Bruce Nauman, Mapping the Studio I (Fat Chance John Cage), Dia Center for the Arts, New York; Sperone Westwater, New York; Museum für Gegenwartskunst, Basel; Ludwig Museum, Cologne

Bruce Nauman, All Action Edit—Mapping the Studio I, Office Edit I, Office Edit II with Color Shift, Flip, Flop & Flip/Flop, Galerie Konrad Fischer, Düsseldorf

Bruce Nauman: Neons, Sculptures, Drawings, Van de Weghe Fine Art, New York

2003

Bruce Nauman: Theaters of Experience, Deutsche Guggenheim, Berlin

2004

Bruce Nauman: Setting a Good Corner (Allegory & Metaphor), Power House Memphis, Tennessee

Bruce Nauman, PKM Gallery, Seoul, South Korea

Raw Materials: The Unilever Series: Bruce Nauman, Tate Modern, London

GROUP EXHIBITIONS

1966

New Directions, San Francisco Museum of Art, San Francisco

The Slant Step Show, Berkeley Gallery, San Francisco

Eccentric Abstraction, Fischbach Gallery, New York

William Geis and Bruce Nauman, San Francisco Art Institute

1967

American Sculpture of the Sixties, Los Angeles County Museum of Art; Philadelphia Museum of Art

1968

The West Coast Now: Current Work from the Western Seaboard, Portland Art Museum, Oregon

Three Young Americans: Krueger, Nauman, Saret, Allen Memorial Art Museum, Oberlin College, Ohio

Documenta 4, Kassel, West Germany

Primary Structure, Minimal Art, Pop Art, Antiform, Galerie Ricke, Kassel, West Germany

Prospect 68: International Vorschau auf die Kunst in den Galerien der Avantgarde, Städtische Kunsthalle, Düsseldorf

1969

Here and Now, Washington University Gallery of Art, St. Louis, Missouri

31st Biennial of Contemporary American Painting, Corcoran Gallery of Art, Washington, D.C.

Young American Artists, Wide White Space, Antwerp

Op Losse Schroeven: Situaties en Cryptostructuren (Square Pegs in Round Holes), Stedelijk Museum, Amsterdam; Museum Folkwang, Essen, West Germany

Live in Your Head: When Attitudes Become Form: Works—Concepts—Processes—Situations—Information; Wenn Attitüden Form werden: Werke—Konzepte—Prozesse—Situationen—Information. Kunsthalle Bern, Switzerland; Museum Haus Lange, Krefeld, West Germany; Institute of Contemporary Arts, London

Anti-Illusion: Procedures/Materials, Whitney Museum of American Art, New York

Nine Young Artists: Theodoron Awards, Solomon R. Guggenheim Museum, New York

Art by Telephone, Museum of Contemporary Art, Chicago

Querschnitt II, Galerie Ricke, Cologne

Time Photography, School of Visual Arts, New York

7 Objects/69, Galerie Rolf Ricke, Cologne

555.087, Seattle Art Museum, World's Fair Pavilion, Seattle Center, Seattle, Washington; Vancouver Art Gallery, University of British Columbia, Vancouver

Kompas 4: Westkunst USA/West Coast USA, Stedelijk van Abbemuseum, Eindhoven, Netherlands; Museum am Ostwall, Dortmund, West Germany; Kunsthalle Bern, Switzerland; Pasadena Art Museum, California; City Museum of St. Louis, Missouri; Art Gallery of Ontario, Toronto; Fort Worth Art Museum, Texas

1970

String and Rope, Sidney Janis Gallery, New York

1.Klischee+AntiKlischee. Bildformen der Gegenwart, Neue Galerie, Aachen, West Germany

Body Movements, La Jolla Museum of Contemporary Art, California

Tokyo Biennale, Tokyo Metropolitan Art Gallery

Information, The Museum of Modern Art, New York

Young Bay Area Sculptors, San Francisco Art Institute, California

Holograms and Lasers, Museum of Contemporary Art, Chicago

Against Order: Chance & Art, Institute of Contemporary Art, University of Pennsylvania, Philadelphia

Whitney Annual: Sculpture 1970, Whitney Museum of American Art, New York

1971

Was die Schönheit sei, das weiss ich nicht (II Biennale Nurnberg), Kunsthalle Nurnberg, Nurnberg, West Germany

11 Los Angeles Artists, Hayward Gallery, London

Sixth Guggenheim International Exhibition, Solomon R. Guggenheim Museum, New York

Klischee Und AntiKlischee, Neue Galerie, Aachen, West Germany

Prospect 71, Städtischen Kunsthalle, Düsseldorf

Works on Film, Leo Castelli, New York

Young American Artists, Wide White Space, Antwerp

Septième Biennale de Paris, Paris

Los Angeles Artists, Arts Council of Great Britain, London

Los Angeles Artists, Palais des Beaux-Arts, Paris

200 Years of American Sculpture, Whitney Museum of American Art, New York

Rooms P.S.1, P.S.1, Institute for Art and Urban Resources, Long Island City, New York

American Artists: A New Decade, The Detroit Institute of Arts; Fort Worth Art Museum

1972

Films by American Artists, Whitney Museum of American Art, New York

Spoleto Festival, Spoleto, Italy

Documenta 5, Kassel, West Germany

USA West Coast, Kunstverein Hamburg, West Germany

1973

Video Tapes by Gallery Artists, Leo Castelli Gallery, New York

American Drawings 1963–1973, Whitney Museum of American Art, New York

Record as Artwork, Galerie Ricke, Cologne

Idea and Image in Recent Art, The Art Institute of Chicago

Prints from Gemini G.E.L., Walker Art Center, Minneapolis

1974

4 x Minimal Art, Galerie Ricke, Cologne

Art/Voir, Centre Georges Pompidou, Musée national d'art moderne, Paris

1975

Light/Sculpture, William Hayes Ackland Memorial Art Center, University of North Carolina at Chapel Hill

Menace, Museum of Contemporary Art, Chicago

Body Works, Museum of Contemporary Art, Chicago

Drawing Now, The Museum of Modern Art, New York; Kunsthalle Zürich, Zurich; Städtische Kunsthalle, Baden-Baden, West Germany; Albertina Museum, Vienna; Sonia Henie-Neils Foundation, Oslo

Functions of Drawings, Rijksmuseum Kröller-Müller, Otterlo, Netherlands

1976

Autogeography, Whitney Downtown Museum, New York

The Seventy-Second American Exhibition, The Art Institute of Chicago

200 Years of American Sculpture, Whitney Museum of American Art, New York

Rooms P.S.1, P.S.1, Institute for Art and Urban Resources, Long Island City, New York

American Artists: A New Decade, The Detroit Institute of Arts, Michigan; Fort Worth Art Museum, Texas

Painting and Sculpture in California: The Modern Era, San Francisco Museum of Art; The National

Collection of Fine Arts, Smithsonian Institution, Washington, D.C.

Functions of Drawings/Seichnen/Bezeichnen, Kunstmuseum Basel

Words at Liberty, Museum of Contemporary Art, Chicago

The Dada/Surrealist Heritage, Sterling and Francine Clark Institute, Williamstown, Massachusetts

Sculpture, Münster, West Germany

Drawing Now, The Museum of Modern Art, New York; Kunsthaus Zürich, Zürich; Staatliche Kunsthalle Baden-Baden, West Germany; Graphische Sammlung Albertina, Vienna; Sonja Henie-Niels Onstad Foundation, Oslo; Tel Aviv Museum, Israel

1977
Whitney Biennial, Whitney Museum of American Art, New York

Drawings for Outdoor Sculpture: 1946–1977, John Weber Gallery, New York; Amherst College, Massachusetts; University of California at Santa Barbara; Laguna Gloria Art Museum, Austin, Texas; Massachusetts Institute of Technology, Cambridge, Massachusetts

Surrogates/Self-Portraits, Holly Solomon Gallery, New York

Works from the Collection of Dorothy and Herbert Vogel, The University of Michigan Museum of Art, Ann Arbor

Documenta 6, Kassel, West Germany

Skulptur Austellung in Münster, Westfälisches Landesmuseum fr Kunst und Kulturgeschichte, Münster, West Germany

Whitney Annual: Sculpture 1977, Whitney Museum of American Art, New York

1978
XXXVIII Biennale di Venezia, Venice, Italy

Salute to Merce Cunningham, John Cage and Collaborators, Thomas Segal Gallery, Boston

Nauman, Serra, Shapiro, Jenney, Blum Helman Gallery, New York

Conceptual Art, Julian Preto Gallery, New York

1979
73rd American Exhibition, The Art Institute of Chicago

New Spaces: The Holographer's Vision, The Franklin Institute, Philadelphia

Great Big Drawing Show, PS1, Institute for Art and Urban Resources, Long Island City, New York

1980
Bruce Nauman, Barry Le Va, Nigel Greenwood Inc., London

Minimal and Conceptual Art aus der Sammlung Panza, Museum für Gegenwartskunst, Basel

The New American Filmmakers Series, Whitney Museum of American Art, New York

Contemporary Art in Southern California, High Museum of Art, Atlanta, Georgia

Contemporary Sculpture: Selections from the Collection of the Museum of Modern Art, The Museum of Modern Art, New York

Donald Judd/Bruce Nauman/Richard Serra: Sculpture, Richard Hines Gallery, Seattle

Master Prints by Castelli Artists, Castelli Graphics, New York

Zeichnungen Neuerwerbungen 1976–80, Museum Haus Lange, Krefeld, West Germany

Architectural Sculpture, Los Angeles Institute of Contemporary Art

XXXVIII Biennale di Venezia, Venice, Italy

American Drawing in Black and White, Brooklyn Museum of Art, New York

Pier+Ocean: Construction in the Art of the Seventies, Hayward Gallery, London; Rijksmuseum Kröller-Müller, Otterlo, Netherlands

1981
New Dimensions in Drawing, The Aldrich Museum of Contemporary Art, Ridgefield, Connecticut

Seventeen Artists in the Sixties, The Museum as Site: Sixteen Projects, Los Angeles County Museum of Art

Neon Fronts: Luminous Art for the Urban Landscape, D.C. Space for Washington Project for the Arts

Drawing Distinctions, Louisiana Museum for Moderne Kunst, Humlebaek, Denmark; Kunsthalle Basel, Switzerland; Städtiche Galerie im Lenbachhaus, West Germany; Wilhelm Hack Museum, Ludwigshafen, West Germany

Space, time, sound; 1970's. A Decade in the Bay Area, San Francisco Museum of Art, California

1982
AntiForm et Arte Povera Sculptures 1966–69, capc Musée d'art contemporain, Bourdeaux, France

Kunst nu/Kunst unserer Zeit, Kunsthalle Wilhelmshaven, West Germany; Groninger Museum, Groningen, West Germany

Reinhard Mucha, Bruce Nauman, Max-Ulrich Hetzler, Stuttgart, West Germany

Documenta 7, Kassel, West Germany

Castelli and His Artists: Twenty-five Years, Aspen Center for the Visual Arts, Colorado; Museum of Contemporary Art, La Jolla, California; Leo Castelli Gallery, New York; Portland Center for the Visual Arts, Oregon; Laguna Gloria Art Museum, Austin, Texas

Attitudes, Concepts, Images, Stedelijk Museum, Amsterdam

Postminimalism, The Aldrich Museum of Contemporary Art, Ridgefield, Connecticut

Sculptors at UC Davis: Past and Present, University of California, Davis

20 American Artists. Sculpture 1982, San Francisco Museum of Modern Art, California

74th American Exhibition, The Art Institute of Chicago

A Century of Modern Drawing from the Museum of Modern Art, New York, The Museum of Modern Art, New York; The British Museum, London; Museum of Fine Arts, Boston; Cleveland Museum of Art, Ohio

1983
De Statua, Stedelijk van Abbemuseum, Eindhoven, Netherlands

American Sculptures from the Permanent Collection, Solomon R. Guggenheim Museum, New York

The Sculptor as Draftsman: Selections from the Permanent Collection, Whitney Museum of American Art, New York

Minimalism to Expressionism: Painting and Sculpture Since 1965 from the Permanent Collection, Whitney Museum of American Art, New York

John Duff, Robert Mangold, Bruce Nauman, Blum Helman Gallery, New York

Works on Paper: Graduate Students from U.C. Davis 1965–1982, Fine Arts Collection, Department of Art, University of California, Davis

Word Works, Walker Art Center, Minneapolis, and the Minneapolis College of Art and Design

1984
Content: A Contemporary Focus, 1974–1984, Hirshhorn Museum and Sculpture Garden, Smithsonian Institution, Washington, D.C.

Bruce Nauman/Dennis Oppenheim: Drawings and Models for Albuquerque Commissions, University Art Museum, University of New Mexico, Albuquerque

Selections from the Collection: A Focus on California, Los Angeles County Museum of Art

Projects: World's Fair, Waterfronts, Parks and Plazas, Rhona Hoffman Gallery, Chicago

An Invitational Exhibit of Neon Art and Sculpture, Madison Gallery, Albuquerque, New Mexico

Night Lights, Dart Gallery, Chicago

L'Architecte est absent. Works from the Collection of Annick and Anton Herbert, Stedelijk van Abbemuseum, Eindhoven, Netherlands

1985

Biennial Exhibition, Whitney Museum of American Art, New York

Selections from the William J. Hokin Collection, Museum of Contemporary Art, Chicago

Transformations in Sculpture, Solomon R. Guggenheim Museum, New York

Affiliations: Recent Sculpture and Its Antecedents, Whitney Museum of American Art, Fairfield County, Stamford, Connecticut

New Work on Paper 3, The Museum of Modern Art, New York

Large Scale Drawings by Sculptors, The Renaissance Society at the University of Chicago

Beuys, Disler, Nauman, Elizabeth Kaufman, Zürich

The Maximal Implications of the Minimal Line, Edith C. Blum Institute, Bard College, Annandale-on-Hudson, New York

Illuminations: The Quality of Light, Pittsburgh Center for the Arts

American Eccentric Abstraction, Blum Helman Gallery, New York

Vom Zeichnen, Aspekte der Zeichnung 1960–1985, Frankfurter Kunstverein, Frankfurt; Kasseler Kunstverein, Kassel, West Germany; Museum Modern Kunst, Vienna

Carnegie International, Carnegie Museum of Art, Pittsburgh

1986

Beuys zu Ehren, Städtische Galerie im Lenbachhaus, Munich

Between Geometry and Gesture: American Sculpture, 1965–1975, Palacio de Velázquez, Madrid

Chambres d'Amis, Museum van Hedendaagse Kunst, Ghent, Belgium

Drawings from the Collection of Dorothy and Herbert Vogel, Department of Art Galleries, The University of Arkansas at Little Rock; Moody Gallery of Art; The University of Alabama, Tuscaloosa; Museum of Art, Pennsylvania State University, University Park

1987

Light, Centro Cultural Arte Contemporáneo, Mexico City

Merce Cunningham and His Collaborators, Lehman Center, Lehman College, New York

Lightworks 1965–86, Rhona Hoffman Gallery, Chicago

Nauman, Serra, Sonnier, Städtiches Museum Abteilberg, Mönchengladbach, West Germany

1967: At the Crossroads, Institute of Contemporary Art, University of Pennsylvania

Skulptur Projekte in Münster, 1987, Westfälischen Landesmuseums für Kunst und Kulturgeschichte, Münster, West Germany

Biennial Exhibition, Whitney Museum of American Art, New York

Avant Garde in the Eighties, Los Angeles County Museum of Art

Committed to Print, The Museum of Modern Art, New York

1988

Planes of Memory—Three Video Installations, Long Beach Museum of Art, California

Zeitlos. Kunst von heite (The Still Presence of the Absent), Hamburger Bahnhof, Berlin

Carnegie International, Carnegie Museum of Art, Pittsburgh

1989

Bruce Nauman, Robert Mangold, Saatchi Collection, London

Seeing is Believing, Christine Burgin Gallery, New York

Bruce Nauman/Richard Long, Musée d'Art Moderne, Saint-Étienne, France

1 Triennal de dibuix Joan Miró, Fundació Joan Miró, Barcelona

Bilderstreit. Widerspruch, Einheit und Fragment in der Kunst seit 1960, Museums Ludwig in den Rheinhallen, Cologne

Image World: Art and Media Culture, Whitney Museum of American Art, New York

Einleuchten (Illuminations), Deichtorhallen, Hamburg

1990

The 60's Revisited: New Concepts/New Materials, Leo Castelli Graphics, New York

Time Span, Fundació Caixa de Pensions, Barcelona

Fragments, Parts, Wholes: The Body and Culture, White Columns, New York

Chris Burden, Mario Merz, Bruce Nauman, Fred Hoffman Gallery, Santa Monica, California

OBJECTives: The New Sculpture, Newport Harbor Museum of Art, Newport Beach, California

Jannis Kounellis, Bruce Nauman, Ulrich Rickriem, Richard Serra, Antoni Tapies, Donald Young Gallery, Chicago

NEONstücke, Sprengel Museum, Hannover, Germany

The Future of the Object: A Selection of American Art, Minimalism, and After, Museum of Contemporary Art, Antwerp

The New Sculpture: 1965–1975: Between Geometry and Gesture, Whitney Museum of American Art, New York; The Museum of Contemporary Art, Los Angeles

Word as Image, American Art 1960–1990, Milwaukee Art Museum; Oklahoma City Art Museum; Contemporary Arts Museum, Houston

1991

Luciano Fabro, Dan Flavin, Jannis Kounellis, Sol LeWitt, Richard Long, Mario Merz, Bruce Nauman, SteinGladstone, New York, with Barbara Gladstone Gallery, New York

Words Without Thoughts Never to Heaven Go, Centraal Museum, Utrecht, Netherlands

Biennial Exhibition, Whitney Museum of American Art, New York

Thirty Years of TB9: A Tribute to Robert Arneson, John Natsoulas Gallery, Davis, California

Inaugural Exhibition, Museum für Moderne Kunst, Frankfurt am Main

Immaterial Objects: Works from the Permanent Collection of the Whitney Museum of American Art, Whitney Museum of American Art, Downtown at Federal Reserve Plaza, New York

Selections From the Elaine and Werner Dannheisser Collection: Painting and Sculpture From the '80s and '90s, Parrish Art Museum, Southampton, New York

Körpereinsatz. Pierre Molinier, Bruce Nauman and Frank West, Galerie Hummel, Vienna

Dislocations: Louise Bourgeois, Chris Burden, Sophie Calle, David Hammons, Ilya Kabokov, Bruce Nauman, Adrian Piper, The Museum of Modern Art, New York

Carnegie International, Carnegie Museum of Art, Pittsburgh

Devil on the Stairs: Looking Back on the Eighties, Institute of Contemporary Art, Philadelphia; Newport Harbor Art Museum, Newport Beach, California

1992

Allegories of Modernism: Contemporary Drawing, The Museum of Modern Art, New York

Documenta 9, Kassel, Germany

Nauman, Oppenheim, Serra: Early Works 1968–71, Blum Helman Warehouse, New York

1993

Gravity & Grace: The Changing Condition of Sculpture, 1965–1975, Hayward Gallery, London

Vito Acconci, Bruce Nauman, Paul Thek, Brooke Alexander Editions, New York

Pour la vie. Gilbert & George, Jeff Koons, Bruce Nauman, capc Musée d'art contemporain, Bordeaux, France

1994

some kind of fact some kind of fiction, Sperone Westwater, New York

1969, Jablonka Galerie, Cologne

Nauman Palermo Schwarzkogler—spaces, The Arts Club of Chicago

1995

Attitudes/Sculptures, 1963–1972, capc Musée d'art contemporain, Bordeaux, France

Critiques of Pure Abstraction, Sarah Blaffer Campbell Gallery, University of Houston; Ilingworth Kerr Gallery of the Alberta College of Art & Design, Calgary, Alberta; Sheldon Memorial Art Gallery, University of Nebraska, Lincoln; Armand Hammer Museum of Art and Cultural Center, University of California, Los Angeles; Crocker Art Museum, Sacramento, California; Madison Art Center, Wisconsin; The Lowe Art Museum, Coral Gables, Florida; Krannert Art Museum, University of Illinois, Champaign; Frederick R. Weisman Museum, University of Minnesota, Minneapolis

1996

Mediascape, Guggenheim Museum Soho, New York

Thinking Print: Books to Billboards, 1980–95, The Museum of Modern Art, New York

Along the Frontier: Ann Hamilton, Bruce Nauman, Francesc Torres, Bill Viola, Soros Center for the Contemporary Art, Kiev, Ukraine

Biennial Exhibition, Whitney Museum of American Art, New York

The Age of Modernism: Art in the 20th Century, Martin-Gropius-Bau, Berlin

Lux/Lumen: Dan Flavin, Bruce Nauman, James Turrell, Félix González-Torres, Fundació Joan Miró, Bercelona

Selections from the Video Collection, The Museum of Modern Art, New York

4e Biennale de Lyon, France

Kwangju Biennale, South Korea

Anselmo, Boetti, Laib, Merz, Nauman, Paolini, Pistoletto, Vital, Zorio, Sperone Westwater, New York

Le miroir vivant. René Magritte, Marcel Broodthaers, Bruce Nauman, Markus Raetz, Musée cantonal des Beaux-Arts, Lausanne, Switzerland

1998

Points of Origin: Sources of Academic Influence, Robert Arneson and Bruce Nauman, Dale Chihuly and Roni Horn, Ron Nagle and John Duff, Franklin Parrasch Gallery, New York

Inner Self: Marcel Duchamp, Marc Quinn, Alberto Giacometti, Bruce Nauman, Robert Gober, Kiki Smith, Mitchell-Innes & Nash, New York

Wounds: Between Democracy and Redemption in Contemporary Art, Moderna Museet, Stockholm

The Edward R. Broida Collection: A Selection of Works, Orlando Museum of Art, Florida

Video: Bruce Nauman, Tony Oursler, Sam Taylor-Wood, San Francisco Museum of Modern Art

Art in New Mexico, Part 1: Works by Agnes Martin, Bruce Nauman, Susan Rothenberg, Richard Tuttle, James Kelly Contemporary, Santa Fe, New Mexico

XXIV Bienal de São Paulo

A Portrait of our Times: An Introduction to the Logan Collection, San Francisco Museum of Modern Art

1999

Afterimage: Drawing through Process, The Museum of Contemporary Art and The Geffen Contemporary, Los Angeles; Contemporary Arts Museum, Houston; Henry Art Gallery, University of Washington, Seattle

The Virginia and Bagley Wright Collection, Seattle Art Museum

Contemporary German and American Art From the Froehlich Collection, Tate Liverpool

Encounter: Bruce Nauman/Kcho, Museum of Contemporary Art, Chicago

Seeing Time: Selections from the Pamela and Richard Kramlich Collection of Media Art, San Francisco Museum of Modern Art, California; Zentrum für Kunst und Medientechnologie, Karlsruhe, Germany

The American Century: Art & Culture 1900–2000, Whitney Museum of American Art, New York

2000

Age of Influence: Reflections in the Mirror of American Culture, Museum of Contemporary Art, Chicago

Samuel Beckett/Bruce Nauman, Kunsthalle Wien Karlsplatz, Vienna

Colour > Light, Fondation Beyeler, Basel

12th Biennale of Sydney, Australia

Food for the Mind. Die Sammlung Udo und Anette Brandhorst, Staatsgalerie moderner Kunst, Munich

Exorcism/Aesthetic Terrorism, Fiery Temperaments in Contemporary Art, Museum Boijmans Van Beuningen, Rotterdam

Contemporary Art and Technology Biennial, Seoul, South Korea

Rodney Graham and Bruce Nauman: …the nearest faraway place…, Dia Center for the Arts, New York

Many Colored Objects Placed Side by Side to Form a Row of Many Colored Objects, Collection of Annick and Anton Herbert, Casino Luxembourg-Forum d'Art Contemporain

Art Light, Galerie Ernst Beyeler, Basel

2001

Saying Seeing: 4 from the Sixties, Leo Castelli Gallery, New York

Making Time, Armand Hammer Museum of Art and Cultural Center, University of California, Los Angeles

Into the Light: The Projected Image in American Art 1964–1977, Whitney Museum of American Art, New York

Nauman, Kruger, Jaar, Daros, Zurich

2002

Between Language and Form, Yale University Art Gallery, New Haven, Connecticut

Conceptual Art 1965–1975 from Dutch and Belgian Collections, Stedelijk Museum, Amsterdam

Life, Death, Love, Hate, Pleasure, Pain: Selected Works from the MCA Collection, Museum of Contemporary Art, Chicago

Video Acts: Single Channel Works from the Collections of Pamela and Richard Kramlich and New Art Trust, P.S.1 Contemporary Art Center, Long Island City, New York; Institute of Contemporary Arts, London

Fantasy Underfoot: The 47th Corcoran Biennial, Corcoran Gallery of Art, Washington, D.C.

2003

The Last Picture Show: Artists Using Photography, 1960–1982, Walker Art Center, Minneapolis; Armand Hammer Museum of Art and Cultural Center, University of California, Los Angeles; Museo de Arte Contemporánea de Vigo, Spain; Fotomuseum Winterthur, Zurich

2004

Singular Forms (Sometimes Repeated): Art from 1951 to the Present, Solomon R. Guggenheim Museum, New York

A Minimal Future? Art as Object 1958–1968, The Museum of Contemporary Art, Los Angeles

Bodily Space: New Obsessions in Figurative Sculpture, Albright-Knox Art Gallery, Buffalo, New York

Beyond Geometry: Experiments in Form 1940s–70s, Los Angeles County Museum of Art, California

SITE Santa Fe, New Mexico

The Beauty of Failure/The Failure of Beauty, Fundació Joan Miró, Barcelona

animals, Haunch of Venison, London

Biennale of Sydney, Australia

PUBLIC COLLECTIONS

Albright-Knox Museum, Buffalo, New York

The Art Institute of Chicago, Illinois

Australian National Gallery, Canberra

The Baltimore Museum of Art

Benesse Art Site Naoshima, Japan

capc Musée d'art contemporain, Bordeaux, France

Centre Georges Pompidou, Musée national d'art moderne, Paris

The Chase Manhattan Bank Art Collection, New York

Crex Collection, Zurich

Dallas Museum of Art

Daros Collection, Zurich

Des Moines Art Center, Iowa

Dia Art Foundation, New York

Fogg Art Museum, Cambridge, Massachusetts

Fundació "la Caixa," Barcelona

Haags Gemeentemuseum, The Hague

Hallen für neue Kunst, Schaffhausen, Switzerland

Hamburger Kunsthalle, Hamburg

Hirshhorn Museum and Sculpture Garden, Smithsonian Institution, Washington, D.C.

Emanuel Hoffmann Foundation, Basel

Kunsthaus Zürich, Zurich

The Modern Art Museum of Fort Worth, Texas

Castello di Rivoli-Museo d'Art Contemporanea, Turin, Italy

Museo Nacional Centro de Arte Reina Sofía, Madrid

Museo d'Art Contemporani de Barcelona

Museu Serralves, Museu de Arte Contemporânea, Porto, Portugal

Museum Boijmans Van Beuningen, Rotterdam

The Museum of Contemporary Art, Chicago

Museum of Fine Arts, Boston

Museum für Gegenwartskunst, Basel

Museum Haus Lange Krefeld, Germany

Museum Ludwig, Cologne

The Museum of Modern Art, New York

Museum für Moderne Kunst, Frankfurt am Main

Pinakothek der Moderne, Munich

Rijksmuseum Kröller-Müller, Otterlo, Netherlands

S.M.A.K.–Stedelijk Museum voor Actuele Kunst, Ghent, Belgium

San Francisco Museum of Modern Art

Solomon R. Guggenheim Museum, New York

Sprengel Museum Hannover, Germany

The St. Louis Art Museum, Missouri

Städtisches Museum Ateiberg, Mönchengladbach, Germany

Stedelijk Museum, Amsterdam

Tate Gallery, London

Vancouver Art Gallery

Walker Art Center, Minneapolis

Whitney Museum of American Art, New York

ZKM | Museum für neue Kunst, Karlsruhe, Germany

SELECTED BIBLIOGRAPHY

Adams, Brooks. "The Nauman Phenomenon," *Art & Auction* (Dec. 1990), 118-24.

Adams, Parveen. "Bruce Nauman and the Object of Anxiety," *October,* no. 83 (Winter 1998), 96-113.

Ammann, Jean-Christophe, Nicholas Serota, and Joan Simon. *Bruce Nauman.* Exhibition catalogue. London: Whitechapel Art Gallery, 1986.

Assche, Christine van. *Bruce Nauman.* Exhibition catalogue. Manchester: Hayward Gallery, 1998.

Auping, Michael. "Bruce Nauman's Yellow Triangular Room," *Artweek* 6, no. 9, 1 Mar. 1975, 5-6.

Auping, Michael. "Bruce Nauman Talks About Mapping the Studio," *Artforum* 40, no. 7 (Mar. 2002), 120-21.

Auping, Michael, and Emma Dexter. *Bruce Nauman: Raw Materials.* Exhibition catalogue. London: Tate Gallery, 2005.

Barnitz, Jacqueline. "In the Galleries: Bruce Nauman," *Arts Magazine* 42, no. 5 (Mar. 1968), 62.

Barth, Frank, and Melitta Kliege. *Bruce Nauman: Versuchsanordnungen Werke 1965–1994.* Exhibition catalogue. Berlin: Hamburger Kunsthalle, 1998.

Benezra, Neal. *Affinities and Intuitions: The Gerald S. Elliott Collection of Contemporary Art.* Exhibition catalogue. Chicago: Art Institute of Chicago, 1990.

Benezra, Neal, et al. *Bruce Nauman: Exhibition Catalogue and Catalogue Raisonné.* Minneapolis: Walker Art Center, 1994.

Bismarck, Beatrice von. *Bruce Nauman: Der Wahre Künstler.* Ostfildern-Ruit: Cantz Verlag, 1998.

Bodel, Aude. "Néon. De l'électricité dans l'art," *Beaux Arts Magazine* (France), no. 8 (Dec. 1983), 52-57.

Bowman, Russell. "Words and images: A Persistent Paradox," *Art Journal* 45 (Winter 1985), 335-43.

Bradley, Kim. "Bruce Nauman: The Private and the Public," *Antiques* 11, no. 3 (Summer 1987), 62-64.

Bruce Nauman: Neons Sculptures Drawings. Exhibition catalogue. New York: Van de Weghe Fine Art, 2002.

"Bruce Nauman Retrospective," *Flash Art,* no. 174 (Jan./Feb. 1994), 41.

Bruggen, Coosje van, Dieter Koepplin, and Franz Meyer. *Bruce Nauman: Drawings 1965–1986.* Exhibition catalogue. Basel: Museum für Gegenwartskunst, 1986.

Bruggen, Coosje van. *Bruce Nauman.* New York: Rizzoli, 1988.

Brundage, Susan, ed. *Bruce Nauman: 25 Years with Leo Castelli.* New York: Leo Castelli Gallery and Rizzoli, 1994.

Buck, Robert. *Here and Now: An Exhibition of Thirteen Artists.* Exhibition catalogue. St. Louis, Missouri: Washington University Gallery of Art, 1969.

Butterfield, Jan. "Bruce Nauman: The Center of Yourself," *Arts Magazine* 49, no. 6 (Feb. 1975), 53-55.

———. "Context: Light and Space as Art," *Journal: A Contemporary Art Magazine* (Los Angeles Institute of Contemporary Art) 4, no. 2 (Spring 1982), 57-61.

Cameron, Dan. "Opening Salvos, Part One," *Arts Magazine* 62, no. 4 (Dec. 1987), 89-93.

Chiong, Kathryn. "Nauman's Beckett Walk," *October,* no. 86 (Fall 1998), 63-81.

Clot, Manel. *Time Span: Jenny Holzer, On Kawara, Bruce Nauman, Lawrence Weiner.* Exhibition catalogue. Barcelona: Fundació Caixa de Pensions, 1990.

Cordes, Christopher, ed. *Bruce Nauman: Prints, 1970–1989: A Catalogue Riasonné.* New York: Castelli Graphics, Lorence-Monk Gallery; Chicago: Donald Young Gallery, 1989.

Cornwell, Regina. "A Question of Public Interest," *Contemporanea* 3, no. 2 (Feb. 1990), 38-45.

Cross, Susan, and Christine Hoffmann. *Bruce Nauman: Theaters of Experience.* Exhibition catalogue. New York: Solomon R. Guggenheim Foundation, 2003.

Danieli, Fidel A. "The Art of Bruce Nauman," *Artforum* 6, no. 4 (Dec. 1967), 15-19.

Dauriac, Jacques Paul. "Paris, Musée d'Art Moderne de la Ville de Paris, Exposition. Electra." *Pantheon* (West Germany) 42, no. 2 (Apr.–June 1984), 188-89.

De Angelus, Michele. "Bruce Nauman Interviews: 1980, May 27–May 30." Transcript, Archives of American Art, Smithsonian Institution, Washington D.C., n. p.

Delacoma, Wynne. "Nauman Wins with Neon: Artist Gets $50,000 in Exhibit," *Chicago Sun-Times,* 6 June 1985, 70.

Dercon, Chris. "Keep Taking it Apart: A Conversation with Bruce Nauman," *Parkett,* no. 10 (Sept. 1986), 54-69.

Domesle, Andrea. *Leucht-Schrift-Kunst : Holzer, Kosuth, Merz, Nannucci, Nauman.* Berlin: Reimer, 1998.

Electronic Art. Elektronische und Elektrische, Objekte und Environments, Neon Objekte (Kalendar 69). Düsseldorf: Verlag Kalendar, 1969.

Elger, Dietmar. *NEONstücke.* Exhibition catalogue. Hannover: Sprengel Museum, 1990.

French, Christopher. "Bruce Nauman: Humor Versus Terror," *Journal of Art* 1, no. 5 (May 1989), 53-55.

Frey, Patrick. "The Sense of Whole," *Parkett,* no. 10 (Sept. 1986), 34-41.

Gardner, Colin. "The Esthetics of Torture," *Artweek* 18, no. 12, 4 Apr. 1987, 7.

Gayford, Martin. "His Raw Materials: Bruce Nauman on His New Installation at Tate Modern," *Modern Painters* (Dec. 2004–Jan. 2005), 69, 73.

Glueck, Grace. "Bruce Nauman: No Body but His," *New York Times,* 1 Apr. 1973, sec. 2, 24.

Graw, Isabelle. "Bruce Nauman: being is nothing," *Flash Art* 26, no. 169 (Mar./Apr. 1993), 71-73.

———. "Just Being Doesn't Amount to Anything (Some Themes in Bruce Nauman's Work)," *October,* no. 74 (Fall 1995), 133-38.

Hickey, Dave. "A Matter of Time: On Flatness, Magic, Illusion, and Mortality," *Parkett,* no. 40/41 (1994), 164-75.

Jones, Ronald, "Bruce Nauman," *Arts Magazine* 59, no. 6 (Feb. 1985), 4.

Kraynak, Janet. "A Rose Has No Teeth: Bruce Nauman 1965–1975." PhD diss., Massachusetts Institute of Technology, Cambridge, Mass., 2001.

———. *Please Pay Attention Please: Bruce Nauman's Words: Writings and Interviews.* Cambridge, Mass.: MIT Press, 2003.

———. "Dependent Participation: Bruce Nauman's Environments," *Grey Room,* no. 10 (Winter 2003), 22-45.

Lauf, Cornelia. "Neon Nights," *Artscribe International,* no. 89 (Nov.–Dec. 1991), 84-85.

Lee, Pamela M. "Pater Nauman," *October,* no. 74 (Fall 1995), 129-32.

Lichtenstein, Therese. "Bruce Nauman: Leo Castelli, Sperone Westwater," *Arts Magazine* 59, no 5 (Jan. 1985), 36.

Linker, Kate. "Bruce Nauman: Leo Castelli Gallery, Sperone Westwater Gallery," *Artforum* 23, no 5 (Jan. 1985), 86-87.

Light/Sculpture. Exhibition catalogue. Chapel Hill: William Hayes Ackland Memorial Art Center, University of North Carolina, 1975.

Lippard, Lucy. *Eccentric Abstraction.* Exhibition catalogue. New York: Fischbach Gallery, 1966.

———. "Eccentric Abstraction," *Art International* 10, no. 9 (Nov. 1966), 28, 34-40.

Livingston, Jane, and Marcia Tucker. *Bruce Nauman: Work from 1965 to 1972.* Exhibition catalogue. New York: Los Angeles County Museum of Art and Praeger, 1973.

Lucht/Kunst. Exhibition catalogue. Amsterdam: Stedelijk Museum, 1971.

Macmillan, Ian. "Wednesday on the Ranch with Bruce Nauman: Cowboy? Artist? Pope?," *Modern Painters* (Dec. 2004–Jan. 2005), 66-73.

McCormick, Carlo. "Bruce Nauman: Sperone Westwater, Leo Castelli," *Flash Art,* no. 120 (Jan. 1985), 42.

Miller, John. "Dada by the Numbers," *October,* no. 74 (Fall 1995), 123-28.

Morgan, Robert C., ed. *Bruce Nauman.* Baltimore: Johns Hopkins University Press, 2002.

Muchnic, Suzanne. *"Vices and Virtues:* Word Association," *Los Angeles Times,* 9 Apr. 1989, C87, 88.

Nachtregels/Night Lines: Words Without Thoughts Never to Heaven Go. Exhibition catalogue. Utrecht: Centraal Museum Utrecht, 1991.

Nauman, Bruce. "Body Works," *Interfunktionen* (West Germany), no. 6 (Sept. 1971), 2-8.

———. "Notes and Projects," *Artforum* 9, no. 4 (Dec. 1970), 44.

———. "False Silences," *Vision,* no. 1 (Sept. 1975), 44-45.

———. "Violent Incident, 1986," *Parkett,* no. 10 (Sept. 1986), 50-53.

Neff, Terry A. R. *Selections from the William J. Hokin Collection.* Exhibition catalogue. Chicago: Museum of Contemporary Art, 1985.

Neon: New Artistic Expression. Greenwich, Conn.: Bruce Museum, 1983.

Ollman, Leah. "Bruce Nauman: Vices and Virtues," *High Performance* 12 (Fall 1989), 42-43.

Olsten, Siegmar, Ellen Joosten, Rudolf Oxenaar, and Katharina Schmidt. *Bruce Nauman, 1972–1981.* Exhibition catalogue. Otterlo: Rijksmuseum Kröller-Müller, 1981.

Parent, Beatrice. "Le Néon dans l'art contemporain," *Chroniques de l'Art Vivant* (France), no. 20 (May 1971), 4-6.

Perrone, Jeff. "'Words': When Art Takes A Rest," *Artforum* 15, no. 10 (Summer 1977), 34-37.

Pincus, Robert L. "The Good, Bad, Dramatic in Nauman's Neon Pieces," *San Diego Union,* 15 Oct. 1988.

———. "Vices and Virtues: An Artistic Flashback," *San Diego Union,* 6 Nov. 1988.

Pincus-Witten, Robert. "Bruce Nauman: Leo Castelli Gallery," *Artforum* 6, no 8 (Apr. 1968), 63-65.

———. "Bruce Nauman: Another Kind of Reasoning," *Artforum* 10, no. 6 (Feb. 1972), 30-37.

Plagens, Peter. "Roughly Ordered Thoughts on the Occasion of the Bruce Nauman Retrospective in Los Angeles," *Artforum* 11, no. 7 (Mar. 1973), 57-59.

———. "I Just Dropped in to See What Condition My Condition Was In," *Artscribe International,* no. 56 (Feb.–Mar. 1986), 22-29.

Puvogel, Renate. "Bruce Nauman. Kämpfer an Mehreren Fronten," *Artis. Zeitschrift für neue Kunst* (June 1992), 16-21.

Raffaele, Joe, and Elizabeth Baker. "The Way-Out West: Interviews with 4 San Francisco Artists," *ARTnews* 66, no. 4 (Summer 1967), 38-41, 75-76.

Richardson, Brenda. *Bruce Nauman Neons.* Exhibition catalogue. Baltimore: Baltimore Museum of Art, 1983.

Roy, Danielle, Luc Courchesne, and Robert White. *Lumière: Perception–Projection.* Exhibition catalogue. Montreal: Centre international d'art contemporain Montréal, 1986.

Russell, John. "Bruce Nauman: Sperone Westwater Gallery and Leo Castelli Gallery," *New York Times,* 12 Oct. 1984, C24.

Saltz, Jerry. "Assault and Battery, Surveillance and Captivity," *Arts Magazine* 63 (Apr. 1989), 13-14.

Schenker, Christoph. "Bruce Nauman: Tears of a Clown," *Flash Art,* no. 158 (May–June 1991), 126.

Schjeldahl, Peter. "Profoundly Practical Jokes: The Art of Bruce Nauman," *Vanity Fair* 46, no. 3 (May 1983), 88-93.

———. "The Trouble with Nauman," *Art in America* 82 (Apr. 1994), 82-91.

Sharp, Willoughby. "Nauman Interview," *Arts Magazine* 44, no. 5 (Mar. 1970), 22-27.

———. "Body Works," *Avalanche,* no 1 (Fall 1970), 14-17.

———. "Bruce Nauman," *Avalanche,* no. 2 (Winter 1971), 22-31.

Silva, Arturo. "Samauel Beckett/Bruce Nauman," *ARTnews* 99, no. 7 (Summer 2000), 220.

Silverthorne, Jeanne. "To Live and to Die," *Parkett,* no. 10 (Sept. 1986), 18-33.

Simon, Joan. "Breaking the Silence: An Interview with Bruce Nauman," *Art in America* 76 (Sept. 1988), 140-49, 203.

Smith, Bob. "Bruce Nauman Interview," *Journal* (Los Angeles Institute of Contemporary Art) 4, no. 2 (Spring 1982), 35-38.

Smith, Roberta. "Art: Bruce Nauman Retrospective," *New York Times,* 30 Oct. 1987, C34.

Sorensen, Jens Erik, ed. *Starlight: James Turrell, Maurizio Nannucci, Bruce Nauman.* Vennely-Stparken, Denmark: Aarhus Kunstmuseum, 1994.

Snyder, Jill, and Ingrid Schaffner. *Bruce Nauman, 1985–1996: Drawings, Prints, and Related Works.* Exhibition catalogue. Ridgefield, Conn.: Aldrich Museum of Contemporary Art, 1997.

Steir, Pat. "The Word Unspoken," *Artforum* 28 (Dec. 1989), 125-27.

Stemmier, Dierck, and Marcia Tucker. *Neon-Kunst. Bruce Nauman, Richard Serra, Keith Sonnier.* Exhibition catalogue. Mönchengladbach: Städtisches Museum Abteiberg, 1987.

Storr, Robert. "Bruce Nauman. Le Fou-pas-si-saint," *Art Press* (France), no. 89 (Feb. 1985), 64-66.

———. "Nowhere Man," *Parkett,* no. 10 (Sept. 1986), 70-90.

Szeeman, Harald, Scott Burton, Grégoire Muller, and Tommaso Trini. *Live in Your Head: When Attitudes Become Forms: Works—Concepts—Processes—Situations—Information.* Exhibition catalogue. Bern: Kunsthalle Bern, 1969.

Taubin, Amy. "Clowning Around," *Village Voice* 34, no. 52, 26 Dec. 1989, 75-76.

Three Decades: The Oliver-Hoffmann Collection. Exhibition catalogue. Chicago: Museum of Contemporary Art, 1988.

Tucker, Marcia. "PheNAUMANology," *Artforum* 9, no. 4 (Dec. 1970), 38-44.

Wallace, Ian, and Russell Keziere. "Bruce Nauman Interviewed," *Vanguard* (Vancouver) (Feb. 1979), 15-18.

Wallach, Amei. "Artist of the Showdown," *Newsday,* 8 Jan. 1989, sec. 2, 4-5, 23.

Warren, Lynn. "Bruce Nauman," *New Art Examiner* 6, no. 8 (May 1979), 13.

Warren, Ron. "Bruce Nauman: Leo Castelli/Sperone Westwater," *Arts Magazine* 59, no. 4 (Dec. 1984), 39-40.

Welish, Marjorie. "Who's Afraid of Verbs, Nouns, and Adjectives?," *Arts Magazine* 64, no. 8 (Apr. 1990), 79-84.

Whitney, David. *Bruce Nauman.* New York: Leo Castelli Gallery, 1968.

Winer, Helene. "How Los Angeles Looks Today," *Studio International* 182, no. 937 (Oct. 1971), 127-31.

Wolfs, Rein. "Bruce Nauman: Director of Violent Incidents," *Parkett,* no. 10 (Sept. 1986), 42-49.

Yau, John. *Bruce Nauman: Selected Works.* Exhibition catalogue. New York: Zwirner & Wirth, 2001.

Young, Joseph E. "Los Angeles," *Art International* 14, no. 6 (Summer 1970), 111-15.

Zutter, Jörg, ed. *Bruce Nauman: Skulpturen und Installationen, 1985–1990.* Exhibition catalogue. Basel: Museum für Gegenwartskunst, 1990.

———. "Alienation of the Self, Command of the Other in the Work of Bruce Nauman," *Parkett,* no. 27 (Mar. 1991), 155-58.

Published by the Milwaukee Art Museum

700 North Art Museum Drive Milwaukee, WI 53202

414-224-3200 www.mam.org

First edition

Distributed by The MIT Press

55 Hayward Street Cambridge, MA 02142-1493 USA

617-253-5646

Designed by Dan Saal

Edited by Lucy Flint

Color separated by Professional Graphics, Rockford, Illinois

Printed in Hong Kong

Library of Congress Cataloging-in-Publication Data

Ketner, Joseph D.

 Elusive signs : Bruce Nauman works with light/essays by Joseph D. Ketner II, Janet Kraynak, Gregory Volk.

 p. cm.

 Catalog of an exhibition at the Milwaukee Art Museum Jan. 28-Apr. 9, 2006 and at six other places.

 Includes bibliographical references.

 ISBN 0-944110-83-5

 1. Nauman, Bruce, 1941---Exhibitions. 2. Installations (Art)--United States--Exhibitions. 3. Neon lighting in

art--Exhibitions. 4. Light in art--Exhibitions. I. Nauman, Bruce, 1941- II. Kraynak, Janet. III. Volk, Gregory. IV.

Milwaukee Art Museum. V. Title.

 N6537.N38A4 2006

 709.2--dc22

 2005030764

COVER IMAGE

Mean Clown Welcome, 1985 (detail). Udo and Anette
Brandhorst Collection, Cologne
(fig. 56)